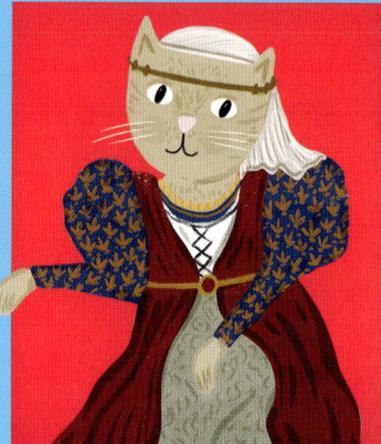

ILLUSTRATED BY
NIA GOULD

WRITTEN AND EDITED BY JOCELYN NORBURY

DESIGNED BY BABS WARD
COVER DESIGN BY ANGIE ALLISON

Manufacturer: First published in Great Britain in 2026 by LOM ART, an imprint of Michael O'Mara Books Limited, 9 Lion Yard, Tremadoc Road, London SW4 7NQ
www.mombooks.com

Represented by: Authorised Rep Compliance Ltd, Ground Floor, 71 Lower Baggot Street, Dublin D02 P593, Ireland
www.arccompliance.com

W www.mombooks.com/lom

f Michael O'Mara Books

o @lomart.books

A CIP catalogue record for this book is available from the British Library.

ISBN: 978-1-915751-51-5

10 9 8 7 6 5 4 3 2 1

This product is made of material from well-managed, FSC®-certified forests and other controlled sources. The manufacturing processes conform to the environmental regulations of the country of origin.

Printed in November 2025 by Leo Paper Products Ltd, Heshan Astros Printing Limited, No.16 Yanjiang Road, Gulao Town, Heshan, 529738, Guangdong, China.

For further information see www.mombooks.com/about/sustainability-climate-focus
Report any safety issues to product.safety@mombooks.com

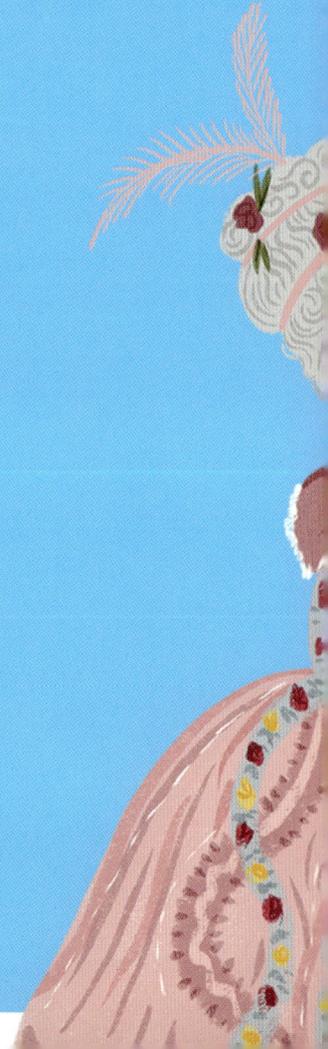

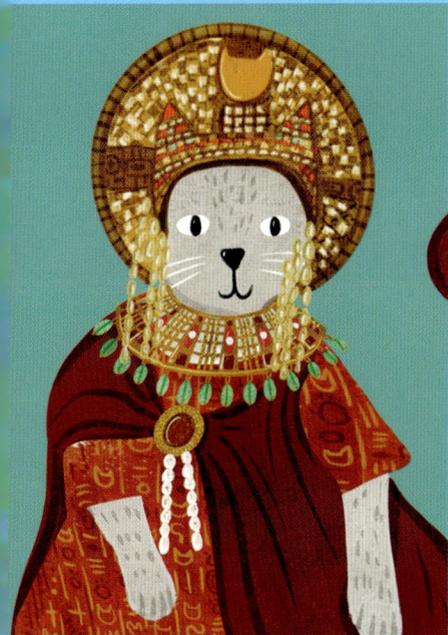

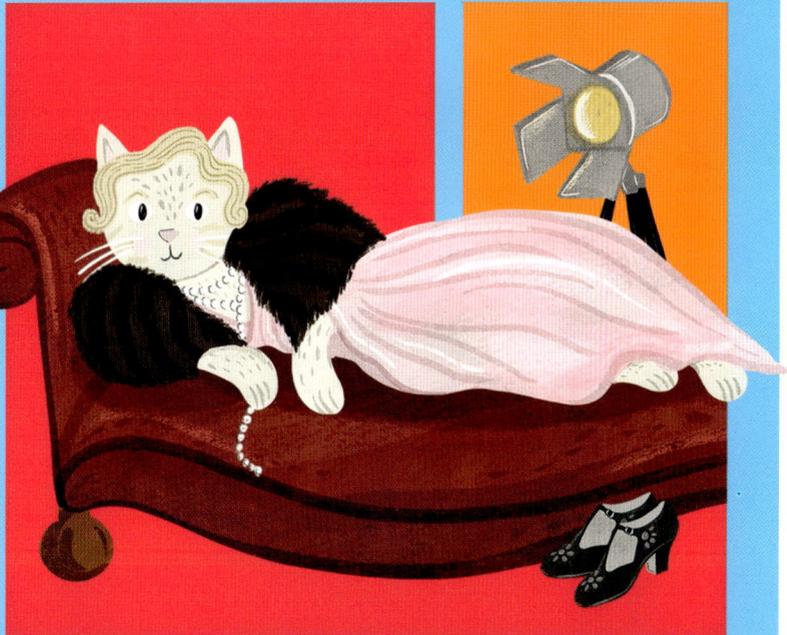

A HISTORY OF FASHION
IN 21 CATS

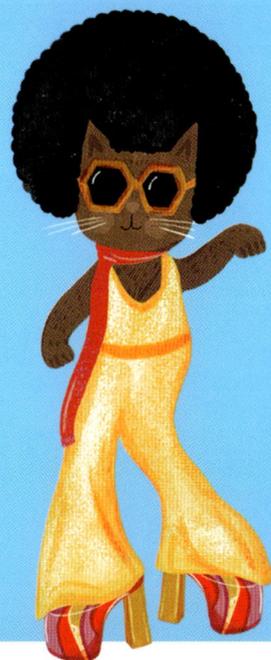

LOM ART

INTRODUCTION

Get ready to take a playful "catwalk" through the fascinating world of fashion. A cast of fashionable felines brings to life 21 iconic eras, with each cat striking a pose to showcase key trends—from the refined elegance of the ancient Egyptians to the flannel-fueled angst of 1990's grunge.

Accompanying each chic cat is a breakdown of the individual elements of their look, designed to give an insight into the cultural and historical context that helped shape the trends, as well as the stars who wore them and the designers who created them. Pounce into history's most stylish moments and marvel at how different cultures and eras have contributed to the rich tapestry of the fashion world today. At the back of the book is an illustrated timeline of the eras featured.

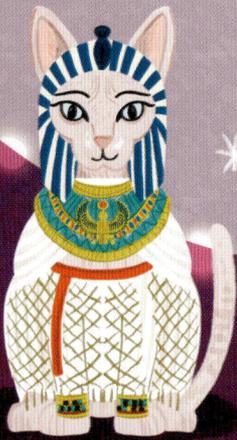

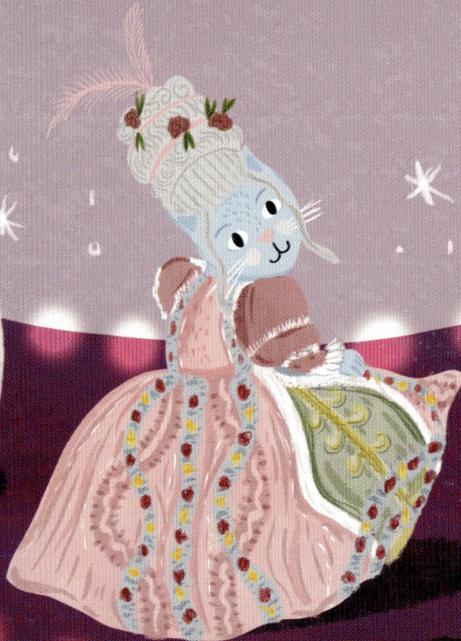

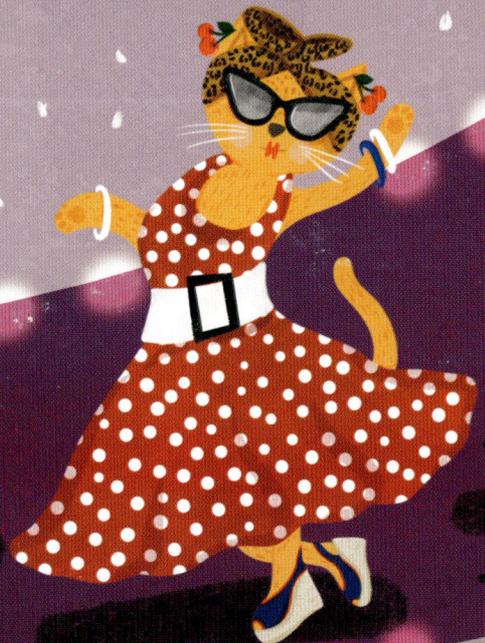

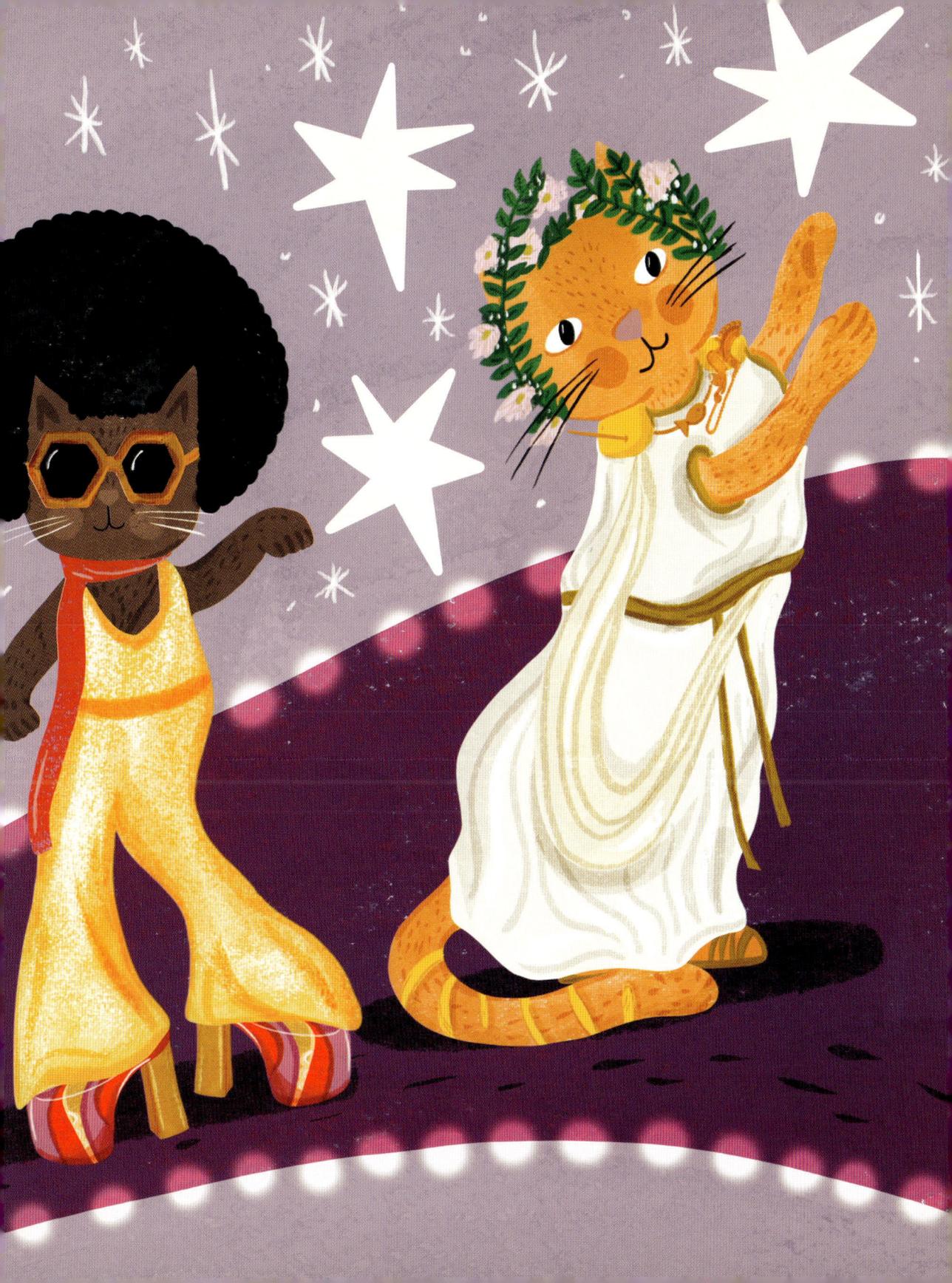

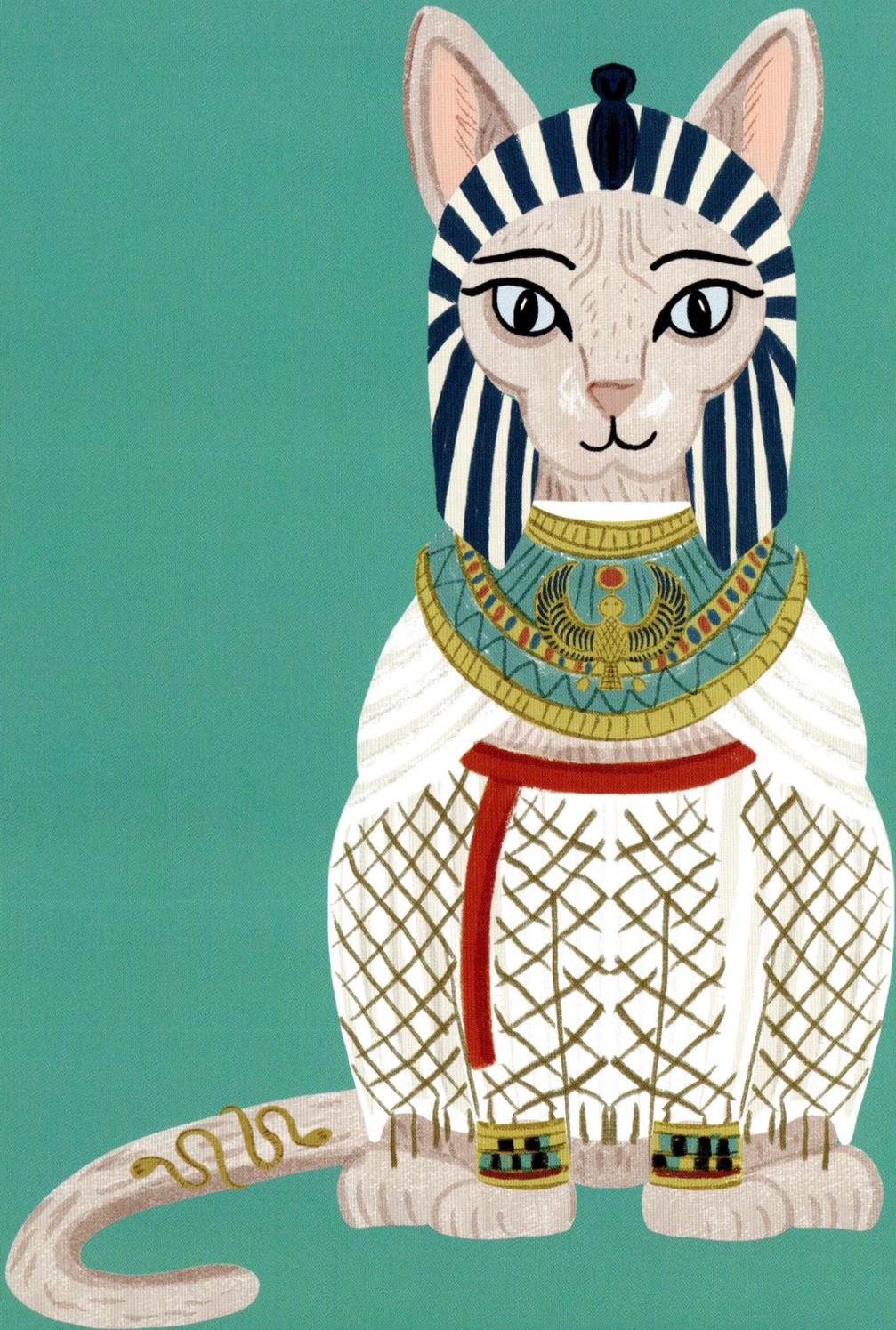

THE ANCIENT-EGYPTIAN CAT

History and fashion collide when you gaze upon the elegant and arresting ancient-Egyptian cat. Taking in almost 3,000 years, from about 3000 BCE to 330 BCE, this long period of time allowed the ancient Egyptians to hone a signature style.

Much of the clothing at this time was influenced by two factors: practicality and class. Most women wore light, linen dresses called *kalasiris*, which were designed to keep them cool in sweltering temperatures. In addition, upper-class women wore fine, embellished linen, decorated with beading, jewels, and other accessories. For others, clothing was kept to a bare minimum, with dresses just substantial enough to offer some protection from the sun without interfering with daily life.

The ancient Egyptians used makeup, wigs, and jewelry to look good, as well as to honor gods and ward off infection. The hieroglyph *nefer*, meaning "beautiful," was even used in names. Egyptian style was so iconic and striking that it continues to inspire fashion to this day.

FASHION QUEEN

Charismatic and beautiful, Cleopatra left a lasting impression for her sharp wit and strong sense of personal style. With elaborate flowing robes, embellished with rich embroidery and beading, not to mention her signature kohl eyeliner, this style queen is surely one of the earliest fashion icons.

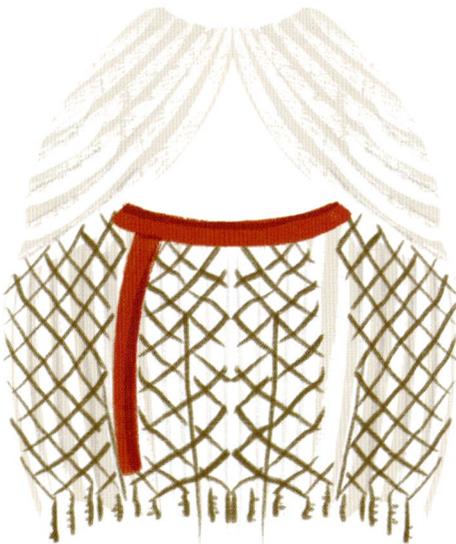

JEWELED COLLARS

For upper-class ancient Egyptians, fashion was all about the accessories. They could demonstrate their wealth by wearing elaborate collars around their necks. It was also thought that these beaded neckpieces pleased the gods.

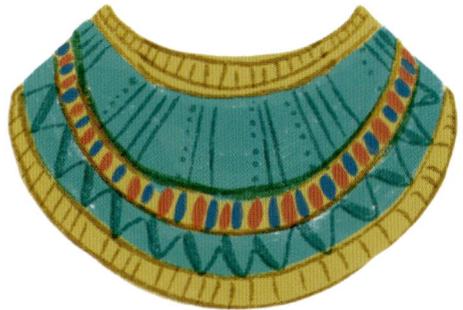

JEWELS

The ancient Egyptians often used gold for their accessories, sometimes adding colored enamel for extra pizzazz. Some jewelry had religious meaning, but often it was worn purely for style.

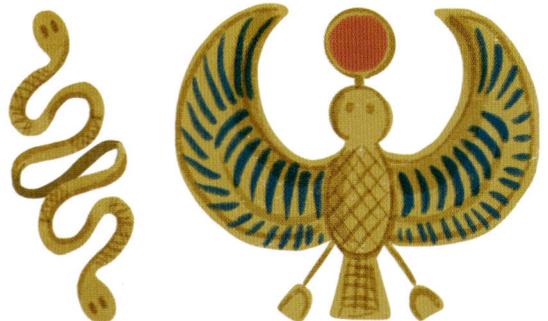

BEAUTIFUL BEADS

This intricately beaded dress was a status symbol, worn by those who could afford it. Sometimes there was no other clothing underneath—nudity was not frowned upon in ancient Egypt!

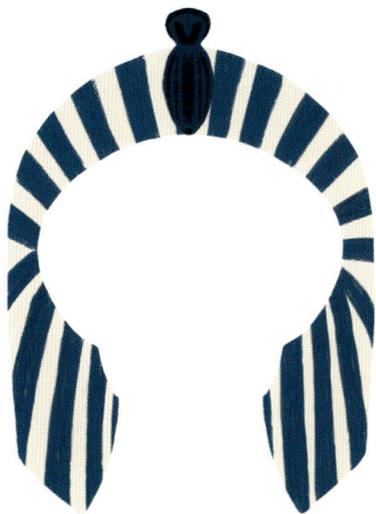

HEADDRESS

Called a *nemes*, this iconic headdress, which was only worn by the pharaoh, was made of starched linen (not metal as Tutankhamun's sarcophagus might lead us to believe) and was often striped.

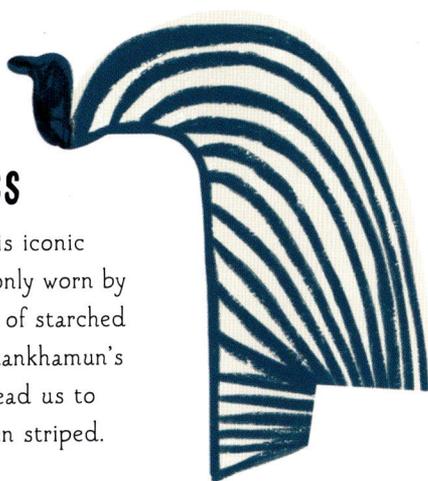

HAIR FREE

Thought to be more hygienic, some ancient Egyptians, male and female, shaved their heads and bodies. They might sometimes use wigs, but it wouldn't be unusual for them to go about their daily lives without.

PURELY COSMETIC

The ancient Egyptians were masters of makeup. Both men and women commonly wore oils and perfumes, as well as eye and facial paints. Eye makeup in particular was extremely popular. Applying kohl around the eyes was believed to enhance their appearance and protect them from the harsh sun and potential eye infections.

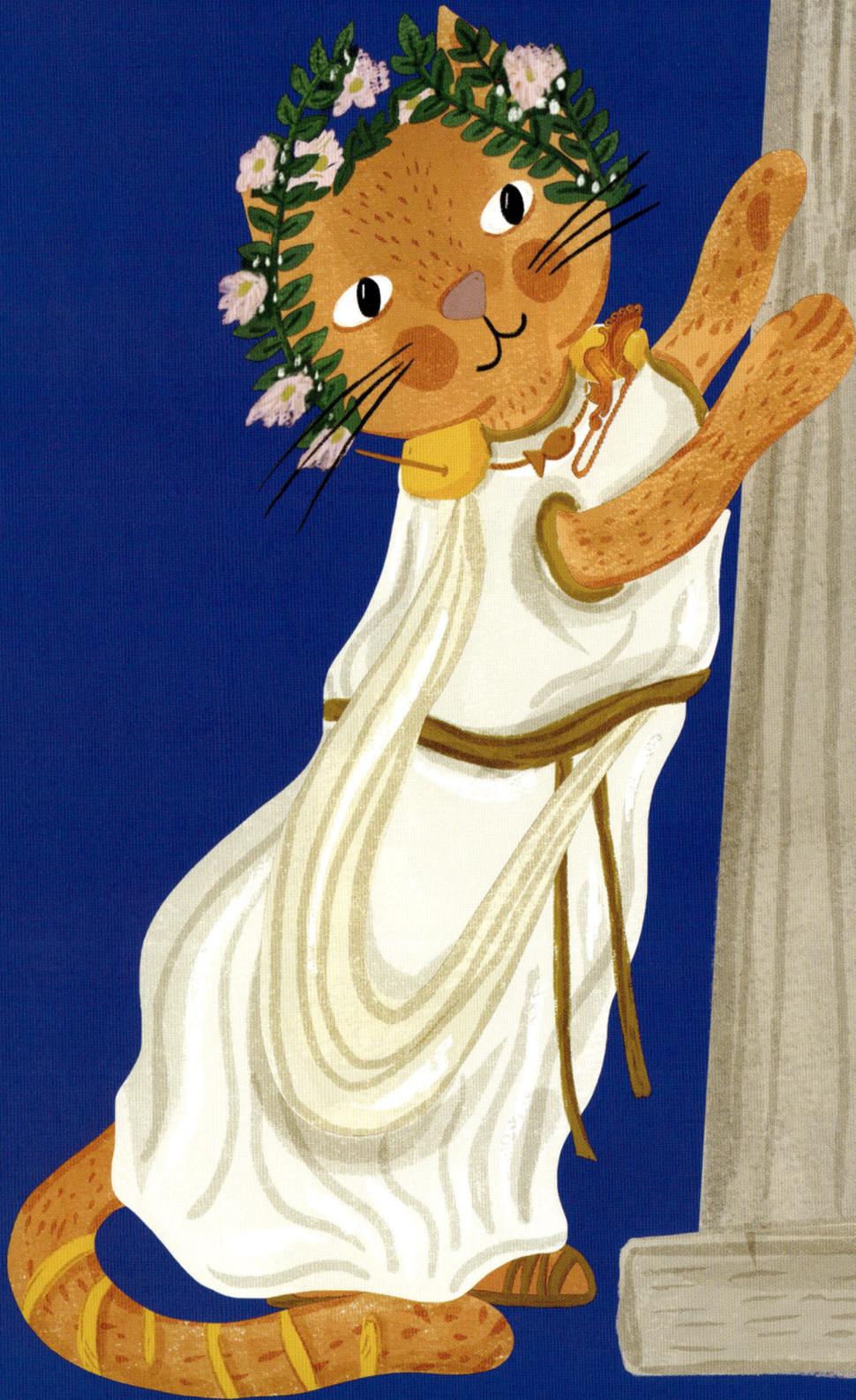

THE ANCIENT-GREEK CAT

Forget tight-fitting or restrictive outfits—for the ancient-Greek cat, comfort was key. Purrfect for lounging, elegant linen and soft, draped fabrics were the order of the day throughout this period.

The original icons of effortless style, the ancient Greeks mastered the art of wrapping fabric to look both sophisticated and comfortable. The go-to outfit was the *chiton*, a simple tunic made from a rectangular piece of fabric, pinned at the shoulders and cinched at the waist. Alternatively, they might choose a *himation*, a type of cloak, or a *peplos*, a heavier folded garment only worn by women. Then there was the *chlamys*, a short cape favored by soldiers and travelers.

Focused on ease of movement and keeping cool in the hot Mediterranean sun, ancient-Greek fashion is both timeless and easily recognizable today.

HAIR ACCESSORIES

Women's hair was worn long, usually with curls or waves on the forehead and sides, and pulled into a chignon at the nape of the neck. They might also decorate their hair with flowers, jewels, or hairpieces. Some women wore wigs instead, which came in many different colors.

CHITON

Easy, breezy, and elegant, the *chiton* was a tunic-like garment, made from a piece of fabric pinned together at the shoulders. Originally made of imported linen, women sometimes wore a version in silk.

STICK A PIN IN IT

Similar to a brooch or pin, *fibulae* were used to fix clothing in place, usually at the shoulders.

JEWELRY

Though clothing was simple, jewelry was important in ancient Greece, particulary during the Hellenistic period. Women adorned themselves with with gold earrings, hairpins, and belts (called girdles), while men sported signet rings.

Soft, draped fabrics were the order of the day throughout this period.

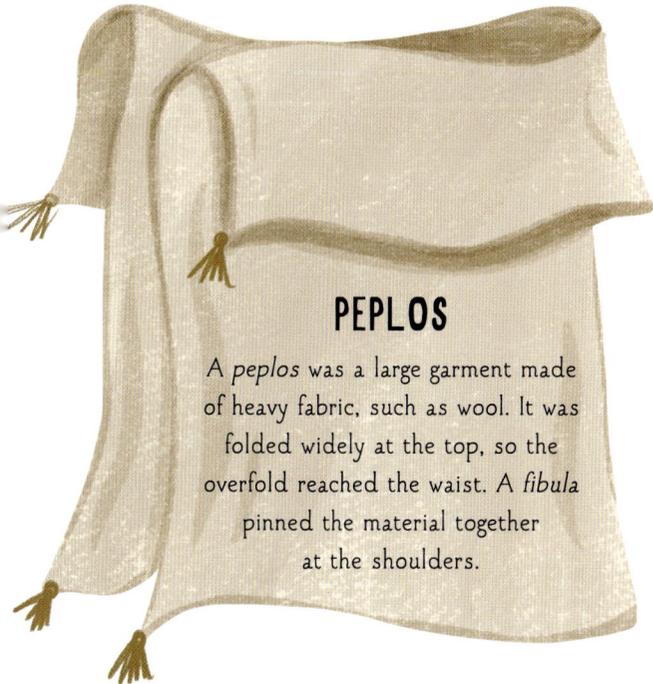

PEPLOS

A *peplos* was a large garment made of heavy fabric, such as wool. It was folded widely at the top, so the overfold reached the waist. A *fibula* pinned the material together at the shoulders.

SANDALS

Although bare feet were a common sight in ancient Greece, when a little more protection was required, both men and women wore sandals. They often had many straps and were made from leather.

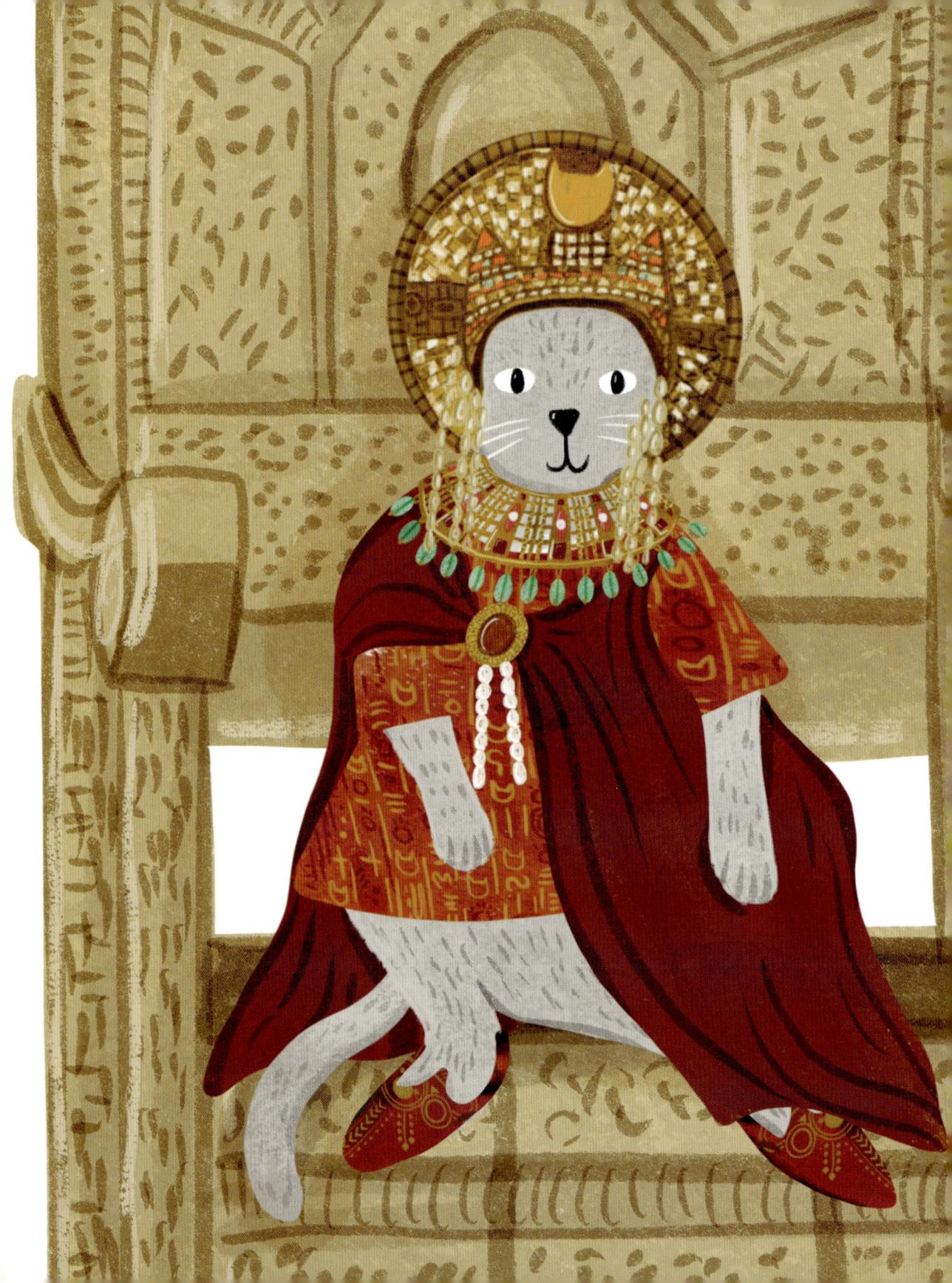

THE BYZANTINE CAT

Grandeur, opulence, and symbolism—the wealthy sophisti-cats of the Eastern Roman Empire knew how to make an impact with their glamorous attire. Although fashions changed over the course of the thousand-year empire, tunics, dresses, and flowing robes were the staples. Accessories, such as richly decorated fabrics, gold jewelry, and intricately embellished shoes, added eye-catching details.

Crowns and veils added a lavish touch. Layers of luxurious fabrics like silk and velvet were often enhanced with elaborate patterns and embroidery. Color was important, too— the brighter and more intense the color, the more expensive the fabric. Purple was the most prestigious, reserved for the emperor and his inner circle. It was known as "imperial purple," made from rare and expensive dye, available only to the wealthiest.

The Byzantine style wasn't merely about aesthetics, it was a way to show status. The more lavish the garments, the higher the social rank.

PEARLS

Pearls were considered to be exceptionally precious to the Byzantine people, who believed they were created when lightning struck an oyster shell. Their rarity, as well as the difficulty in acquiring them, led to pearls being highly valued.

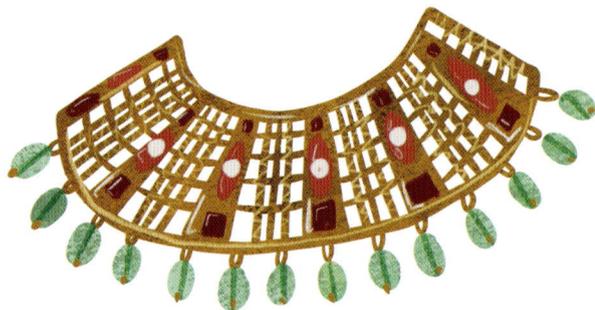

IMPERIAL CROWN

Designed to highlight the power and authority of the wearer, these elaborate headpieces were worn by emperors and empresses during formal ceremonies and special occasions. Encrusted with jewels and pearls, these crowns symbolized the wealth of the empire.

BEJEWELED COLLAR

Noblewomen in the Byzantine era often wore large, ornate neckpieces, frequently inset with gems. These eye-catching pieces acted as wearable art, demonstrating the social status of the wearer.

COIN JEWELLERY

It was common to use gold coins in jewelry, which acted like miniature portraits of the emperor. Some even thought such pieces could offer protection to the wearer.

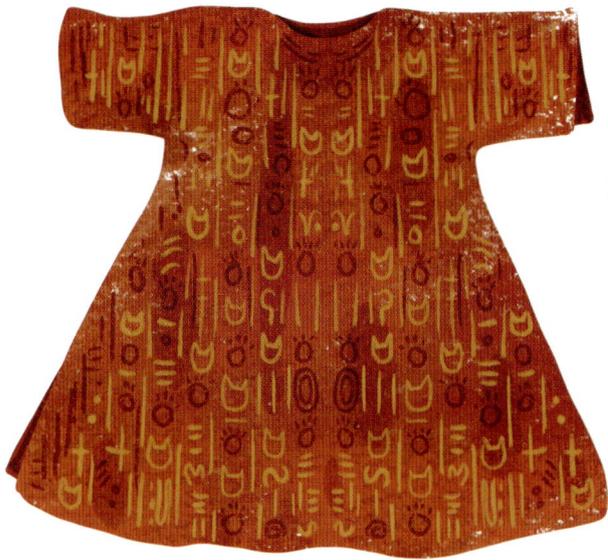

DALMATIC

Worn by both men and women, this was a short tunic-like garment with broad sleeves. The Byzantines were fans of color and pattern, and this garment could be decorated with gold appliqué or other decoration.

CHLAMYS

The *chlamys* was a hip-length cloak that fastened at the right shoulder. It was popular throughout the Byzantine period, and was made from a half-circle piece of material. A longer version, to the ankles, was called a *paludamentum*.

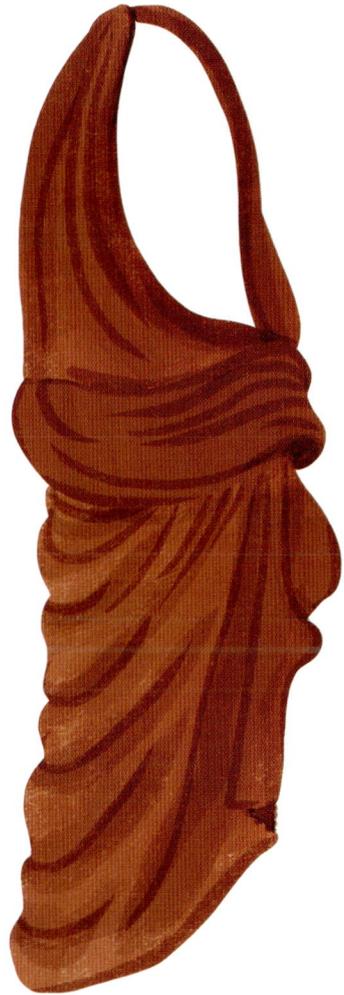

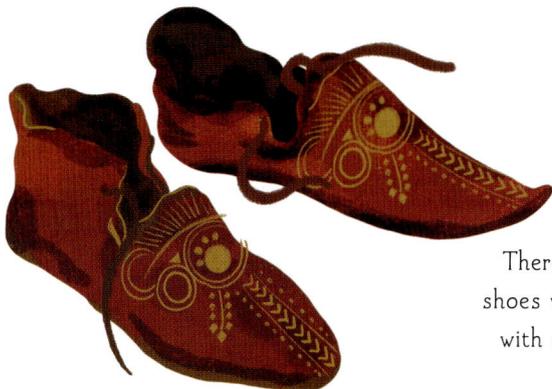

SOLE TO SOLE

There is evidence to suggest that Byzantine shoes were probably based on Roman footwear, with embroidery detail added as a result of influences from the Middle East.

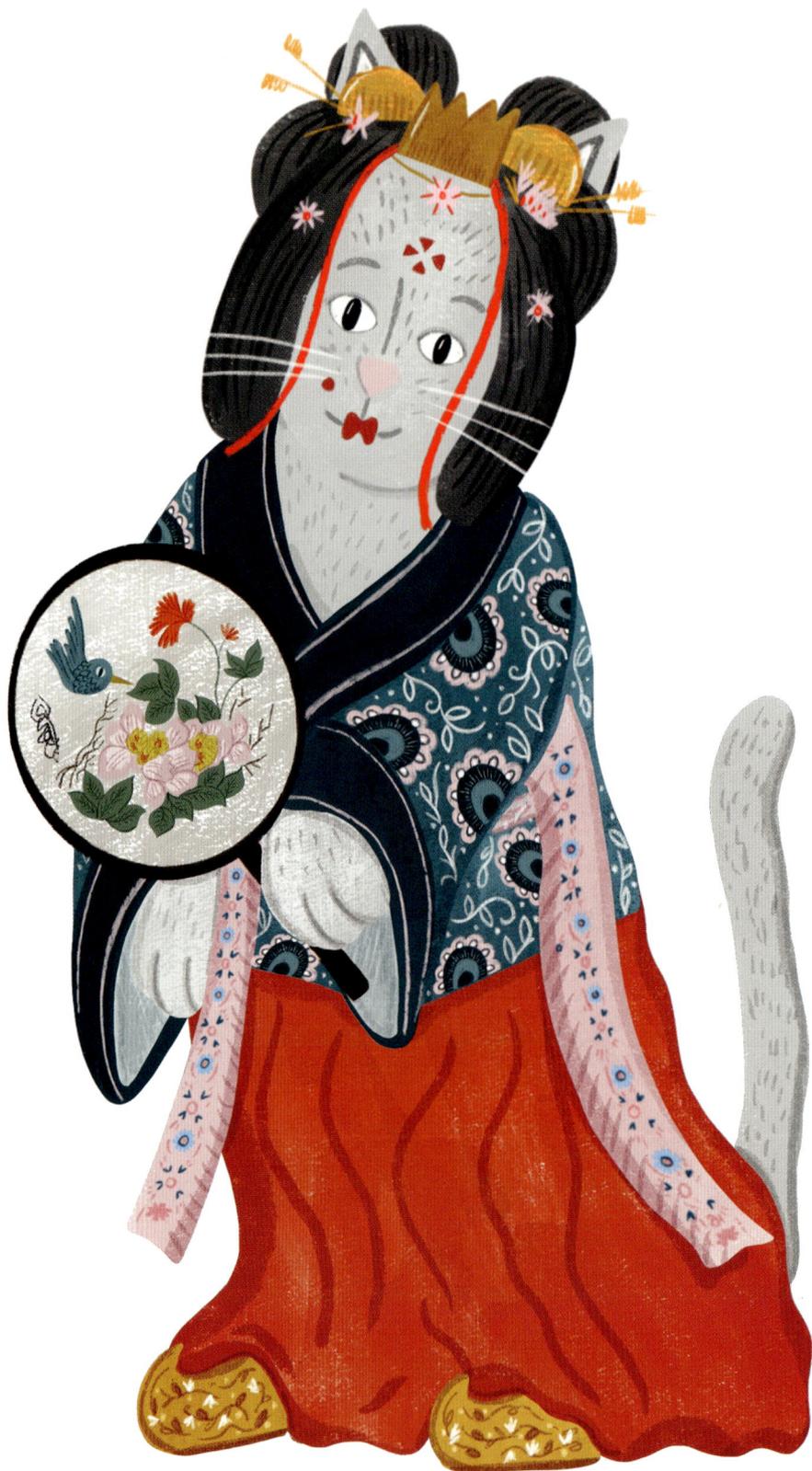

THE TANG—DYNASTY CAT

The ultimate blend of elegance, vibrancy, and flair, Tang-Dynasty fashion reflected the thriving cultural scene in China from 618 to 907 CE. Moving away from muted colors and stiff silhouettes, the energetic Tang era was all about bold hues, flowing fabrics, and statement sleeves. Meow!

Extravagant and exciting, women favored wide-sleeved robes with high waistlines, known as *ruqun*. These were often paired with flowing skirts that made them look as if they were gliding rather than walking. Men wore straight, elegant robes, often in deep blues, reds, and golds. Officials and people of status flaunted embroidered details, designed to show off their rank. One of the most iconic Tang fashion trends was the use of bold makeup. Women sported bright-red lips and delicate, flower-shaped face decorations with dramatically arched brows.

Tang-Dynasty fashion was both fun and expressive. The bold use of color and tailoring was way ahead of its time.

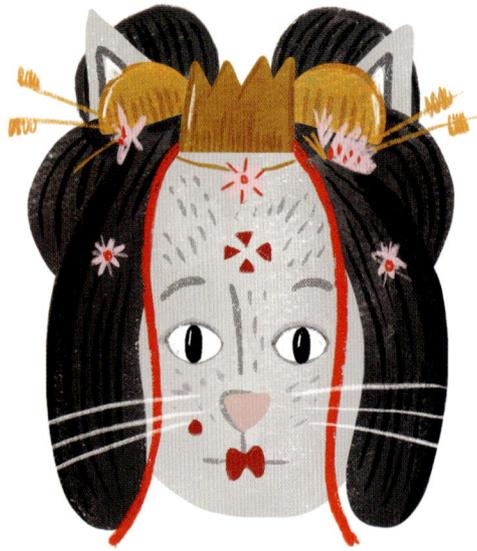

HAIRSTYLES

Hairstyles played a significant role in the look of Tang-Dynasty women. High buns, either single or double, not only appeared elegant and dignified, but also indicated social status and identity. Accessories such as hairpins added to the overall look.

RU

The traditional *ru* was a double-layered or padded, short jacket. The *ru* was worn with a *qun* and together they were known as a *ruqun*.

QUN

The *qun* was a wraparound skirt, usually red in the early Tang Dynasty, becoming more varied and looser as the dynasty progressed.

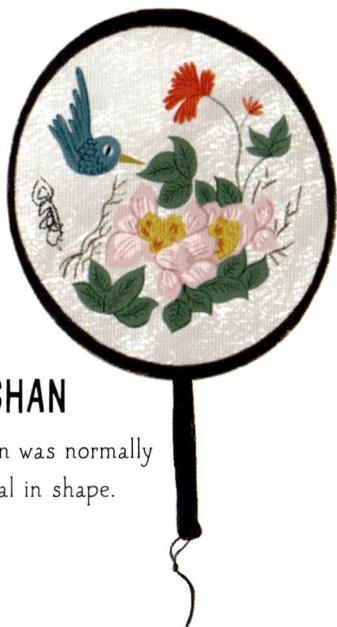

TUANSHAN

This silk hand fan was normally circular or oval in shape.

TRADITIONAL SHOE

Various styles of shoe were popular, and they could be made from brocade, silk, or even woven from Pu grass. An important feature was the raised toe, which would support the hem of the clothes and prevent tripping.

PATTERN AND FABRIC

Silk was often used during this period, with patterns and embroidery adding an element of opulence.

PIBO

This decorative silk shawl was worn as an extra layer. Many portrayals of women from this time show them wearing a stretch of fabric that hangs from arm to arm, across the back. The shawl was called a *pibo* or *pizi*, meaning "ribbon" or "cape," according to its shape.

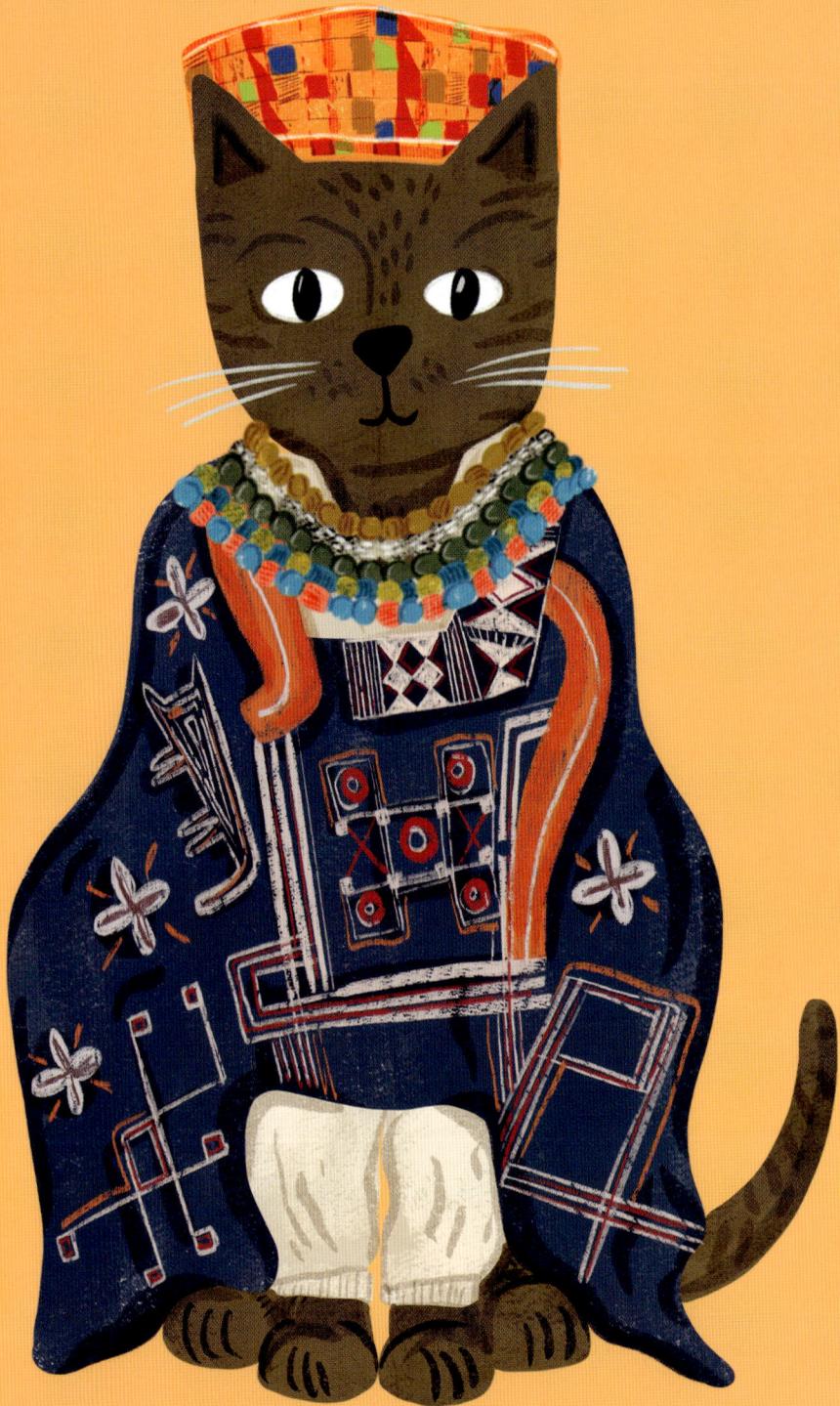

THE EARLY AFRICAN CAT

Early African fashion, from the 8th century onward, was as vibrant, diverse, and expressive as the continent itself, with color, texture, and meaning stitched into every outfit. Across regions and cultures, people dressed not only for the climate but also for ceremony and status.

Woven textiles like *kente* and *adire* turned everyday dressing into an art form. Colors and patterns told stories of heritage and power. Woven fabrics, beads, and shells were fashion staples. The *boubou*, a wide-sleeved kaftan-like garment, gained a prominence that would carry through to the present day. Materials were locally sourced by necessity, but craftsmanship was exemplary and creativity was limitless.

This early period of fashion in Africa was about more than appearances. Despite substantial variations across the continent, clothing was universally used as a spiritual, political, and social statement—
a wearable language spoken across myriad cultures.

BOUBOU

Worn by men, the *boubou* was an over-the-head, robelike
garment with wide sleeves. The *boubou*'s patterns were
symbolic, with the meanings changing for different regions
and ethnic groups. For example, indigo dyeing, which
creates a rich blue color, was considered
prestigious in some regions.

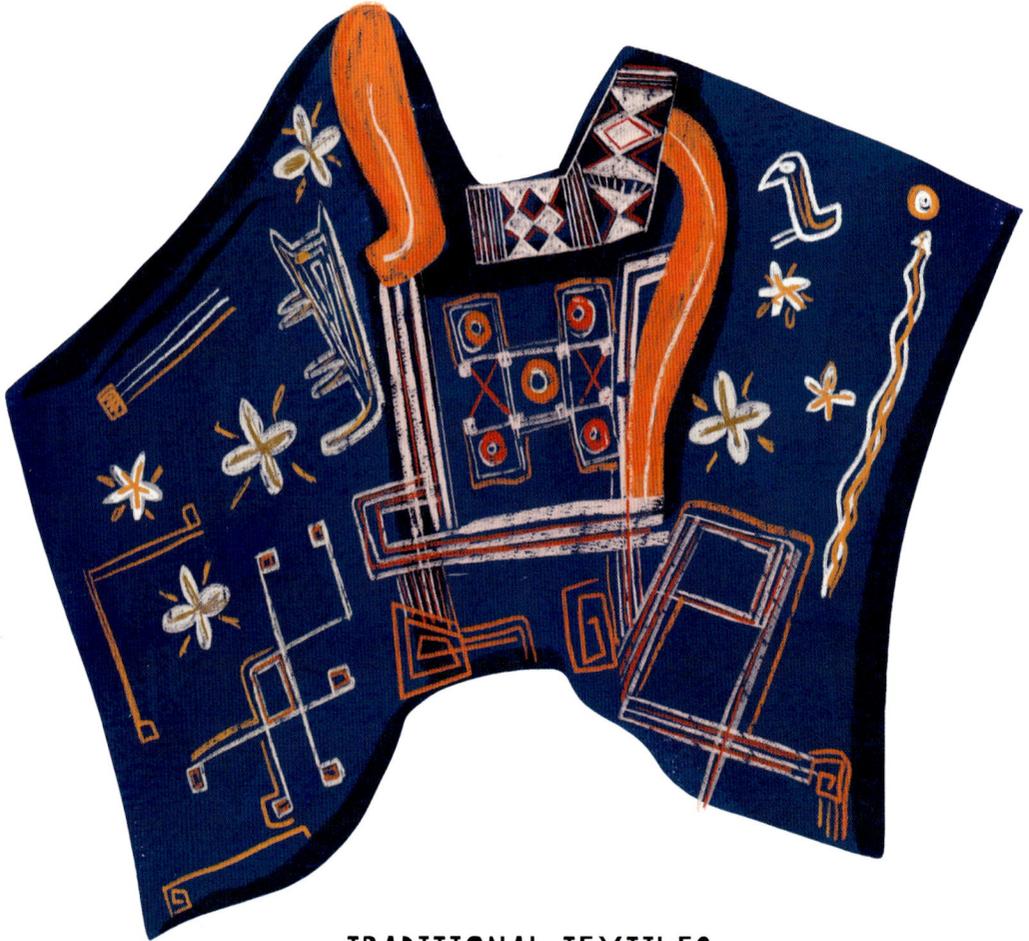

TRADITIONAL TEXTILES

Weaving was practiced across the continent as early as the
8th century, with evidence of early textile production found
in North Sudan and the Republic of Niger. Cameroon was
famous for its tree-bark fabric, while other regions used
animal hides, fur, and even feathers to great effect.

KUFI

The *kufi* hat has a long history in West Africa, where it's a part of the national costume and worn by men of distinction and honor. It's a symbol of respect and can be worn by grandfathers and other older men to represent their wisdom and status.

COWRIE SHELLS

Traders are credited with bringing cowrie shells to West Africa, likely along the trans-Saharan trade routes, around the 8th century. Initially, they may have been used for decoration or ritual purposes, but their small size, durability, and difficulty to forge meant they were later used as a means of payment.

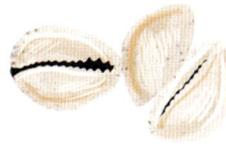

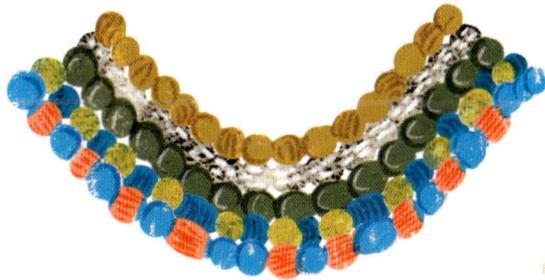

BEADS

In 8th-century West Africa, glass beads were a significant item of trade and were found in archeological contexts, particularly at sites like Gao and Ife. These beads, often of Levant origin, were part of a broader network of exchange that included other goods like ivory and gold.

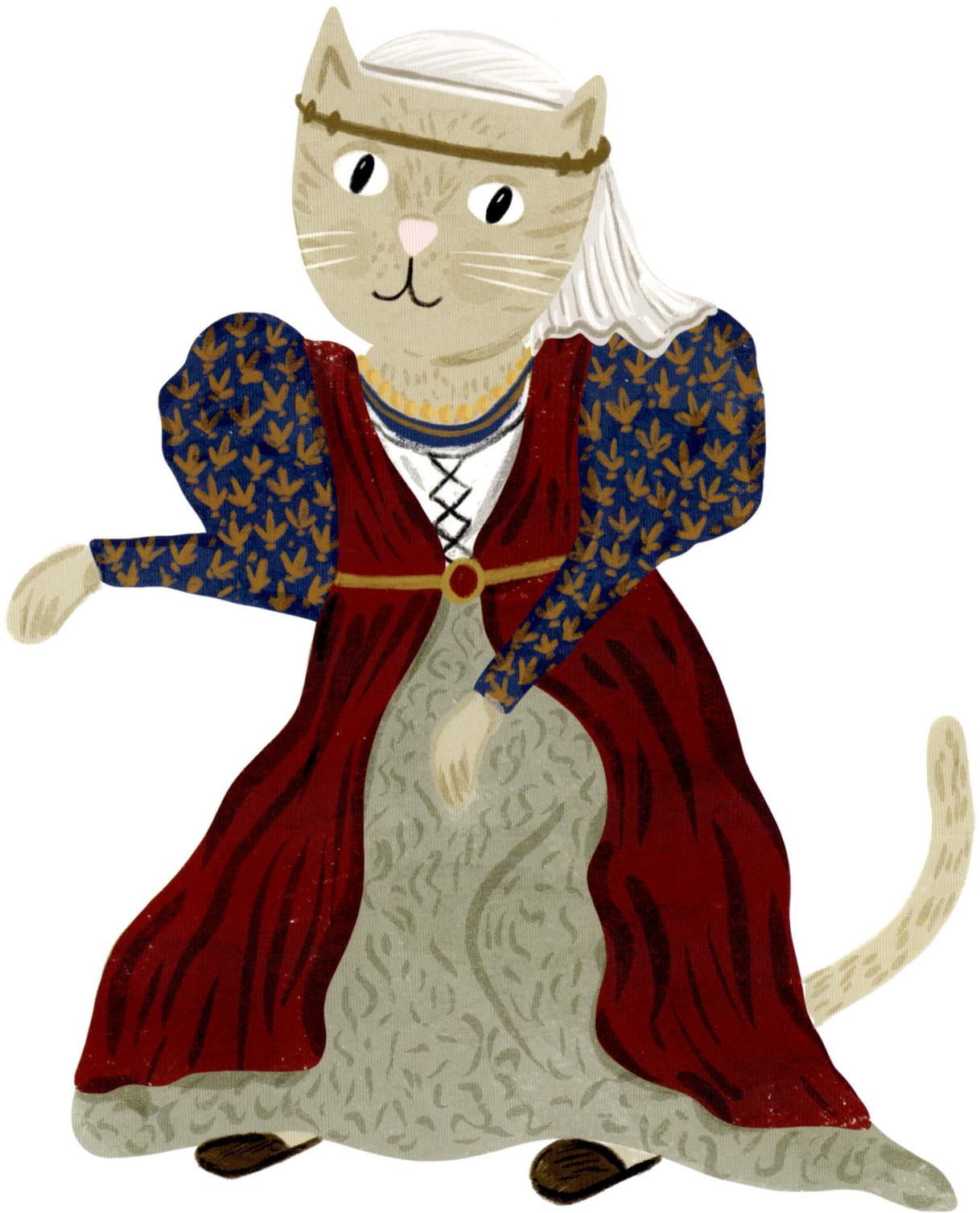

THE QUATTROCENTO CAT

Quattrocento fashion—aka 15th-century Italian style—was a masterclass in style and flair. Like walking, talking Renaissance paintings, men strutted their stuff in doublets and hose, set off by pointed shoes that could rival modern stilettos for impracticality. Tunics were often slashed to reveal the colorful fabric underneath.

Women's fashion was no less fabulous. They floated about in gowns with square necklines and tight bodices that made waistlines look impossibly tiny, with contrasting sleeves that were puffed at the top and fitted in the lower part of the arm. Hair was pulled back tightly under jeweled nets and veils, or braided into elaborate, gravity-defying styles.

Quattrocento fashion played a defining role in the cultural and social structure of the period. Rich colors, imported silks, and elaborate embroidery were designed to show off the wealth and social mobility of the wearer. Fashion during this period was both a celebration of individuality and a clear nod to the Renaissance spirit: bold, beautiful, and over-the-top.

GAMURRA

This was a fitted dress, typically featuring a bodice and full skirt. Often worn under an overdress like the *giornea*, the *gamurra* had detachable sleeves in a contrasting pattern to the skirt. The bodice featured lacing at the front, which provided decorative detail and also allowed for adjustments to be made to the size and fit.

GIORNEA

Worn over the *gamurra*, this overdress was split to show off the detail of the garment beneath it. A belt high on the waist topped off the look.

HEADS UP

Veils, made of white silk or linen, were secured with a thin jeweled string, called a *lenza*. Different styles of veil could be worn to signify modesty, piety, or mourning.

CHEMISE

A practical, simple undergarment made from undyed linen, the chemise was worn by women of all classes.

Rich colors, imported silks, and elaborate embroidery were designed to show off the wealth and social mobility of the wearer.

BROCADE

The quattrocento was an era that saw a huge growth in the production of luxury fabrics such as silk and velvet. Sumptuous brocades, woven with gold, were worn by those who could afford them.

PIANELLE

Basic and comfortable, the *pianelle* was a flat shoe with a wooden sole, often wrapped in leather. These simple slippers would have provided welcome relief from the *chopine*, a towering platform shoe designed to show off the wearer's status and wealth.

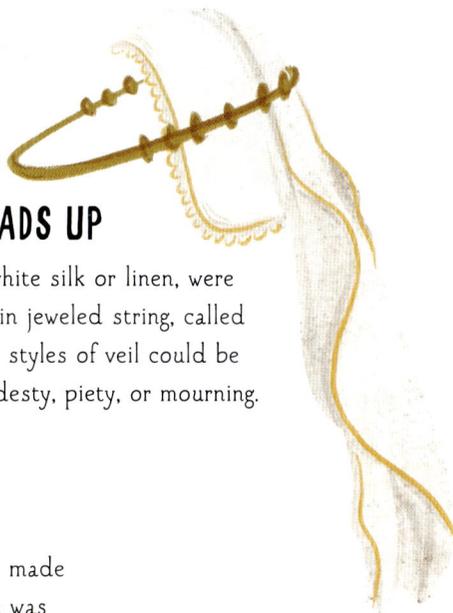

BELT

A narrow belt was worn to cinch the waist and to secure layers of clothing. They were sometimes adorned with elaborate clasps.

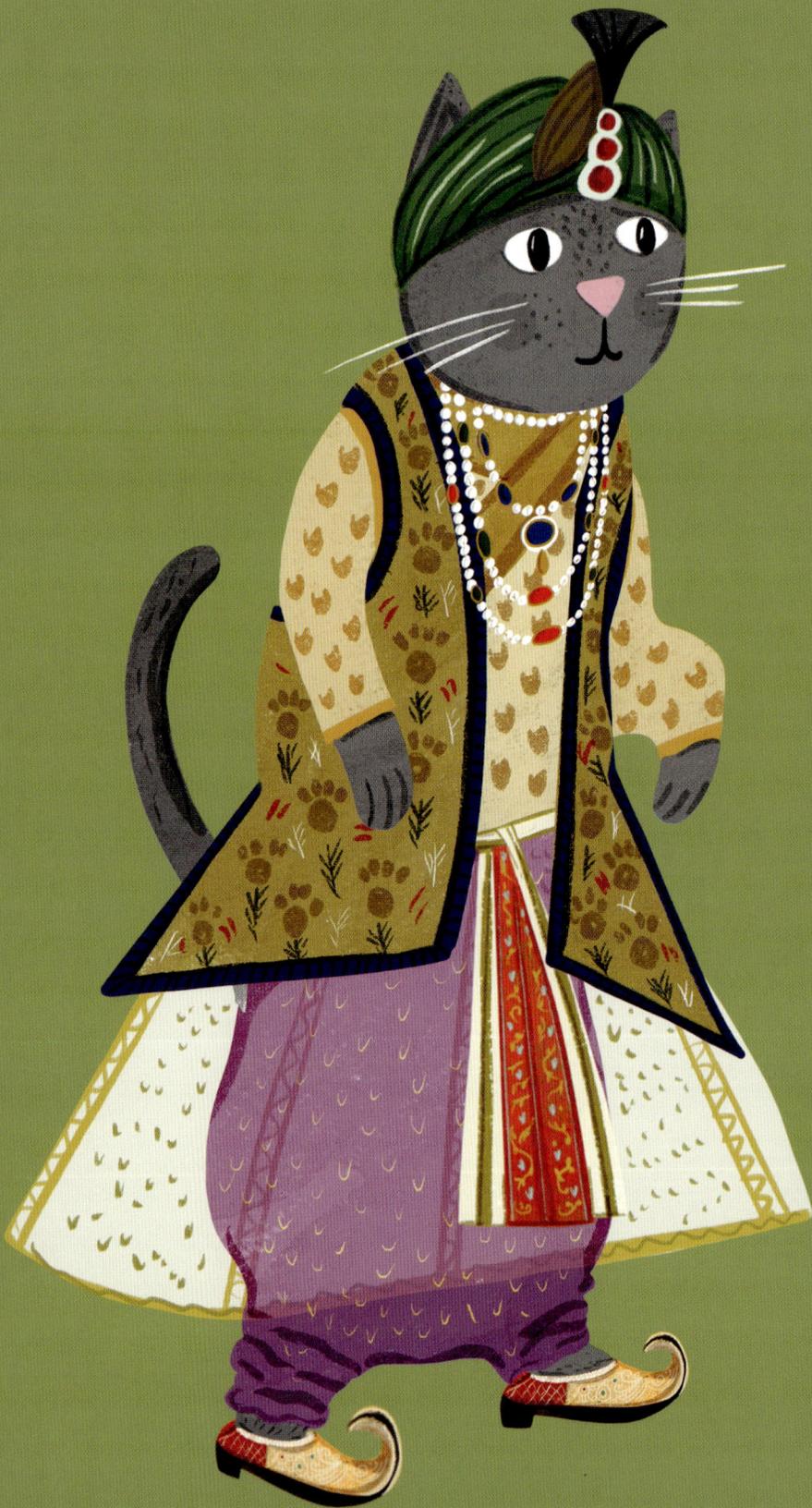

THE MUGHAL CAT

The Mughal era was a golden age for fashionable opulence. A rich fusion of Persian, Central Asian, and Indian styles, clothing was both luxurious and elaborate. Men sported flowing *jamas*, turbans wrapped in a band of contrasting material, and lavish sashes made from the finest silks and brocades. For the very wealthy, no outfit was complete without a splash of sweet-smelling rosewater.

Women wore similar fashions to the men, with the addition of an overskirt. Jewel tones were utilized to flamboyant effect with ruby red, emerald green, and sapphire blue setting off embroidered details. Never afraid to accessorize, the Mughals would drape themselves in nose rings, necklaces, bangles, anklets, and earrings.

Showcasing a rich blend of cultures, fashion during the time of the Mughal court demonstrated an innovative approach to textile design and decoration that continues to flourish in the modern day.

JAMA

The Persian *jama* can refer to a dress, robe, or coat. The Mughal *jama*, however, is a formal coat that fastens at the side. It had a fitted bodice, pulled-in waist, and a knee-length, flared skirt.

CHOGHA

Worn over the *jama*, the *chogha* was a long-sleeved coat or waistcoat, which was left open.

TRADITIONAL SHOE

Mughal men wore ornate shoes, called *jhuti*, with a distinctive, turnup toe.

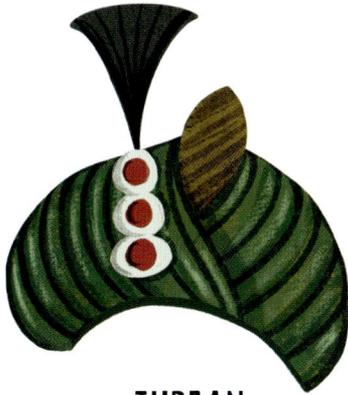

TURBAN

The turban was the Mughal man's most important accessory. An emblem of strength and power, to surrender a turban to anyone was a show of submission. Turban jewels were symbols of the royal family and were only worn on the turbans of the Mughal emperor and his sons.

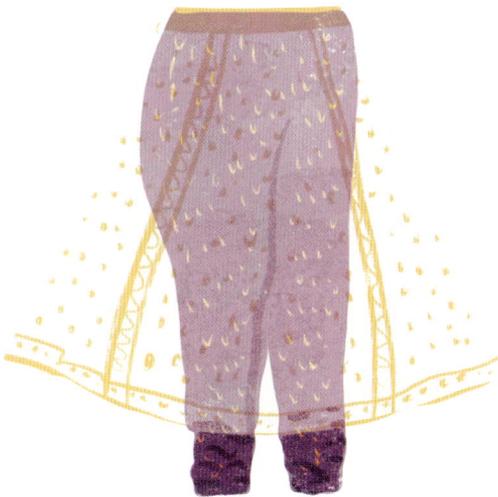

NECKLACES

Jewelry made up an important part of the Mughal look, reflecting the opulence and artistic traditions of the empire. Necklaces featuring precious gems and intricate designs were a symbol of wealth and power and were heavily influenced by Persian and Indian artistic styles.

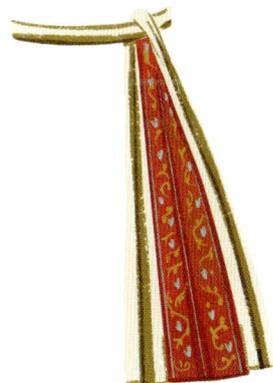

PYJAMA PANTS

Churidar were pants worn loose to the knee, where they then tapered to the ankle. Deliberately long, extra fabric was bunched up around the ankles, creating a pleated effect.

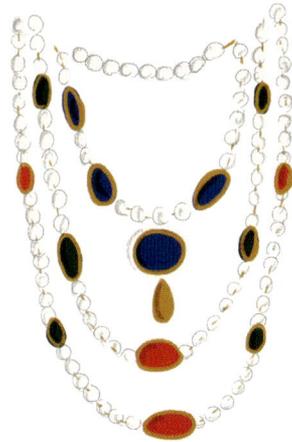

PATKA

Simply a piece of fabric tied around the waist like a sash, the *patka* could be used to hang a ceremonial sword. The *patka* was usually highly decorative, with embroidered edges.

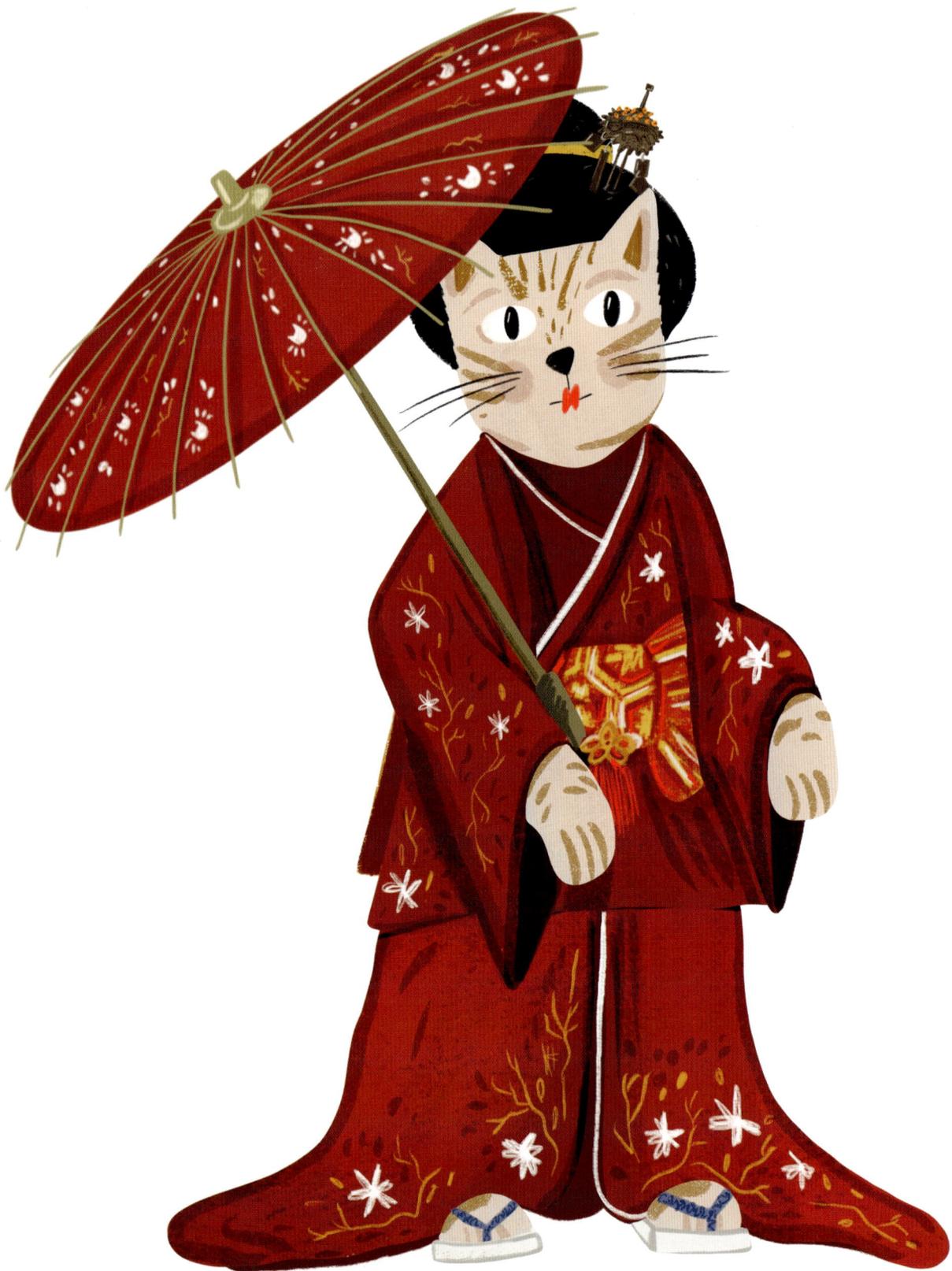

THE EDO CAT

Edo fashion was a demonstration of elegance and understatement, with occasional drama. Clothing was a full-blown expression of social status, artistry, and personal flair. Each social class had their own rules, including what they could wear. By law, commoners such as merchants and artisans had to dress differently to samurai, for example. This meant that budding fashionistas had to be strategic with their choices.

From the 17th to the 19th centuries the kimono ruled supreme. Robes came in stunning patterns such as cherry blossoms, cranes, and waves, and were often layered and belted with wide sashes, called *obi*. Women's kimonos were particularly eye-catching with long sleeves, vibrant hues, and luxurious fabrics. Men often favored more subtle tones, choosing browns, grays, and indigos. Opulent or restrained, even the simplest garments were masterpieces, stitched with precision and artistry.

A moment in fashion history that was awash with contradictions, Edo fashion celebrated both tradition and rebellion. It whispered style rather than shouted, but nevertheless made sure everybody noticed.

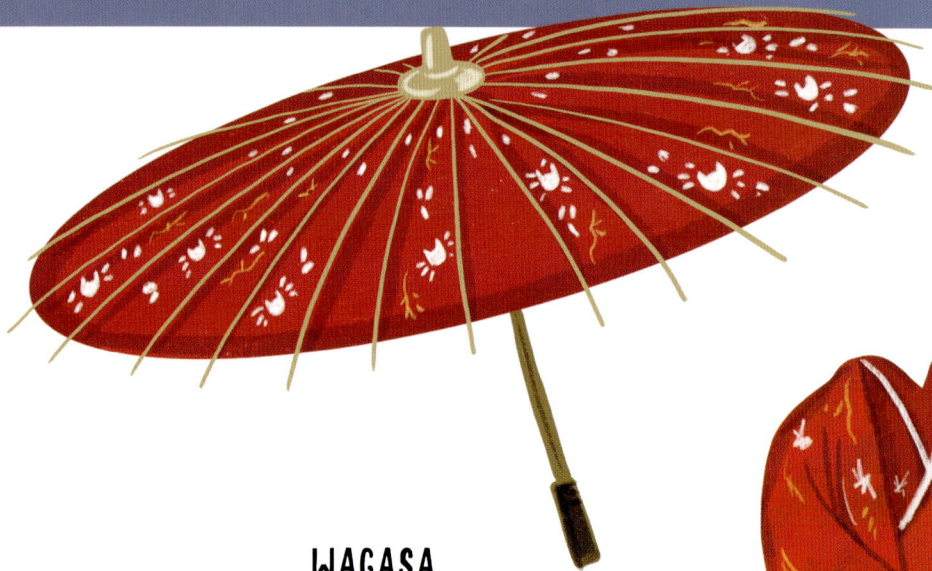

WAGASA

Used for both practical and decorative purposes, the traditional Japanese paper parasol, or *wagasa*, was especially popular in the Edo period. In plain colors or nature-inspired patterns, it was thought to ward off evil spirits and was sometimes used in ceremonies.

KOSODE

Literally meaning "small sleeves," the *kosode* was similar to today's kimonos and was worn by men and women of all classes. A smaller, simpler *kosode* could be worn under an *uchikake* for formal occasions.

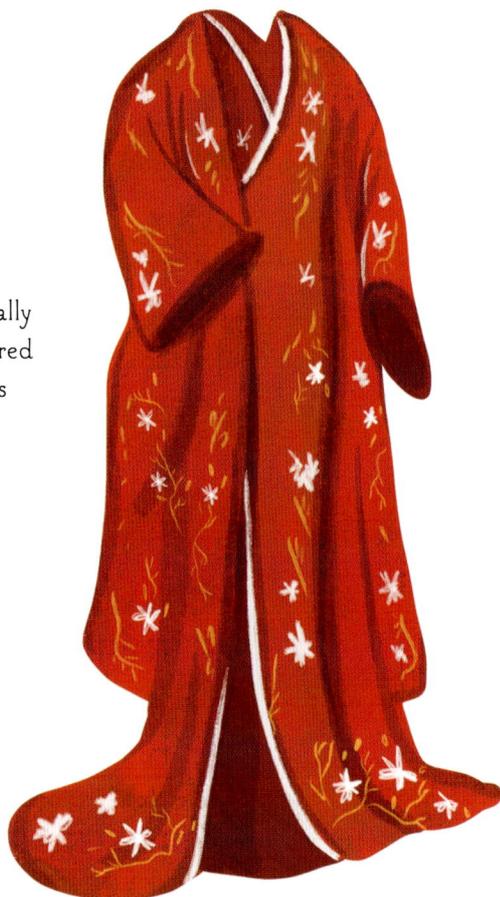

UCHIKAKE

The *uchikake* was worn over a *kosode*, and without a sash, primarily for ceremonies and special occasions. It was a luxurious and formal outer robe for women, often featuring rich colors and intricate patterns to showcase wealth.

HAIR ETIQUETTE

The Edo period was characterized by strict social regulations, including those concerning clothing and hairstyles, which helped differentiate social classes and marital status. Hairstyles of commoners were elaborate but less extravagant than those of courtesans or samurai-class women. *Kanzashi*, a type of hairpin, were frequently worn.

OBI

A status symbol for merchant wives, women would wear their *obi* belt tied at the front to demonstrate that domestic duties would not fall to them.

GETA

This cloglike footwear, called the *geta*, was worn with split-toe socks. The unusual sole construction, with two wooden "teeth," kept the foot raised above the ground. Practical and clean, these shoes signified neatness and propriety.

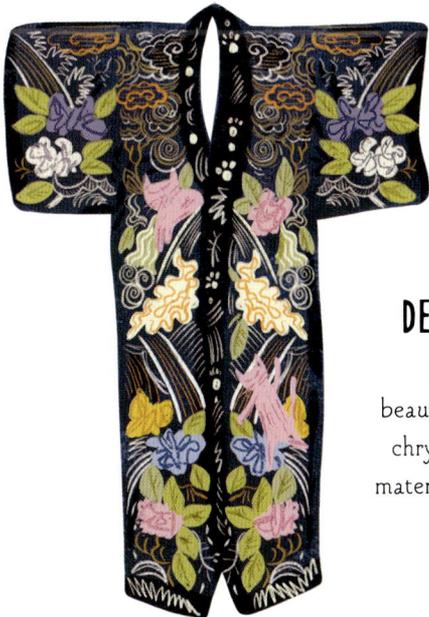

DECORATIVE PATTERNS

Robes were decorated with beautiful designs, such as irises and chrysanthemums. The designs and materials were often chosen to reflect the family's prosperity.

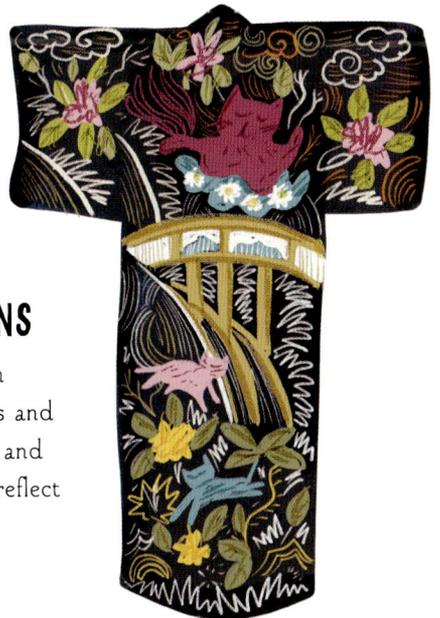

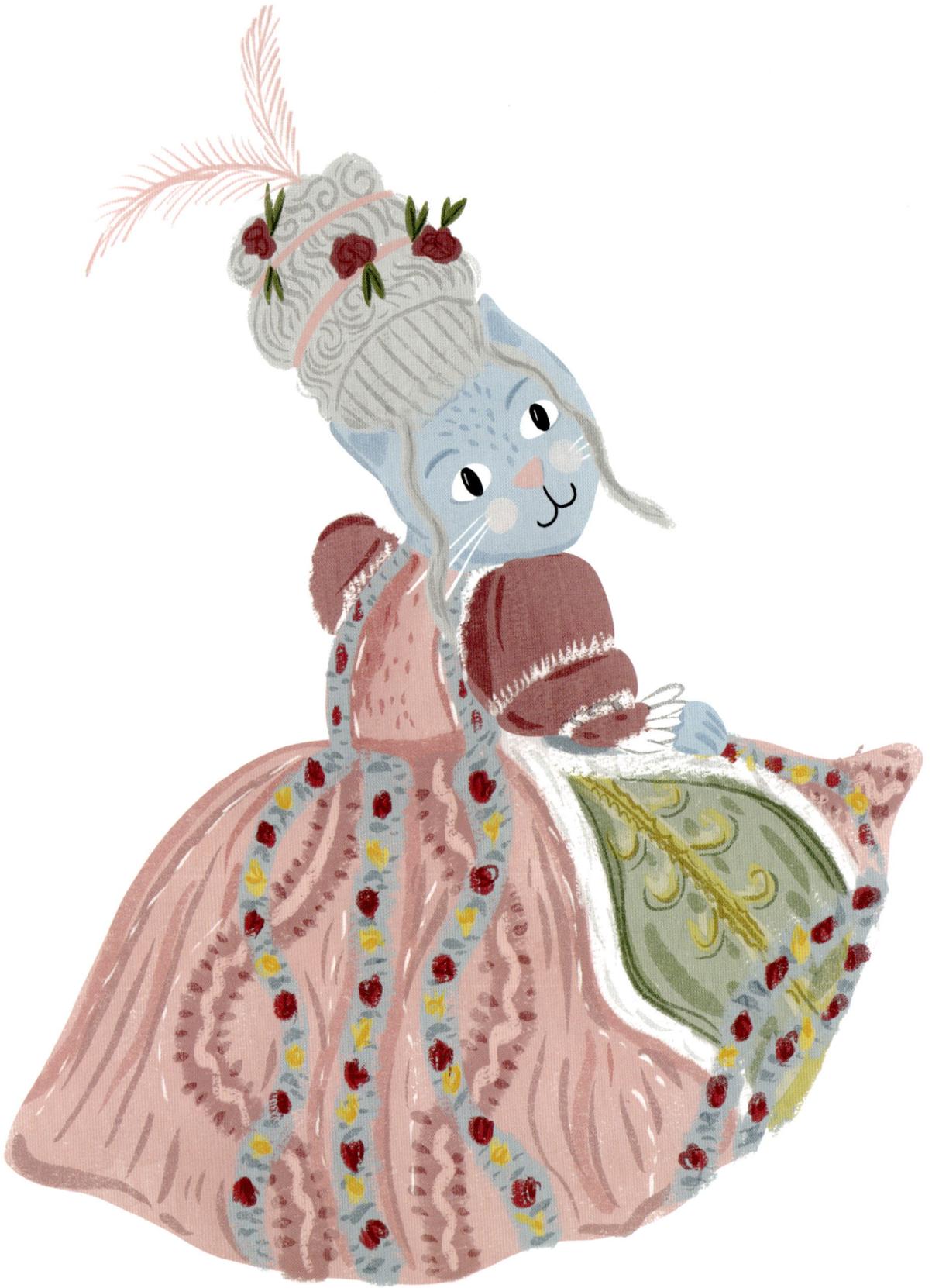

THE ROCOCO CAT

The one thing that Rococo fashion was not was understated. Characterized by frills, ruffles, flounces, and bows, this 18th-century style was all about excess.

Elaborate gowns featured intricate embroidery and layers of frills, while towering headpieces were adorned with feathers, pearls, and lace. Men's fashion was no less outlandish—think velvet coats, silk waistcoats, and knee breeches, complemented by linen cravats and shiny buckled shoes. Rococo was playful and coquettish, reflecting the carefree spirit of the French aristocracy. Marie Antoinette, Queen of France at the time, was a key figure of Rococo extravagance and has become synonymous with the ultraluxe fashions of the era.

Whether attending a ball or taking a turn about the gardens of Versailles, Rococo fashion was an expression of joy and beauty, with a dash of over-the-top fun.

HIGH HAIR

In the late 1760s and '70s, coiffures became increasingly high among the elite. Hair was pomaded, powdered, and shaped around wire frames, with false hair added for extra volume. Embellishments came in the shape of false flowers, bows, pearls, feathers, and even miniature paintings.

TIED UP IN KNOTS

Worn extensively by both men and women, bows could be found on gowns and coats, in wigs, on hats, and decorating almost any other accessory. Madame de Pompadour, mistress of King Louis XV, was a fan of this adornment.

GOWN

For the well-to-do, Rococo fashion was characterized by the iconic *robe à la française*, a gown with distinct back pleats, often adorned with elaborate trimmings and patterns. Hoops worn beneath the skirt, known as *paniers*, were an essential element, extending the hips out sideways and defining the Rococo silhouette.

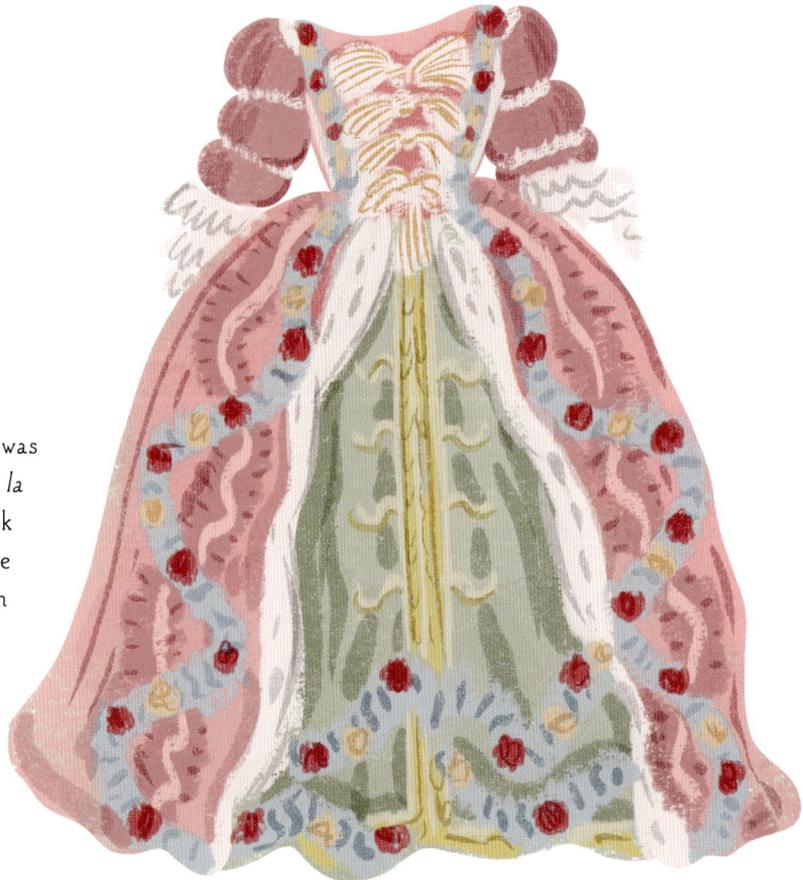

"Let them eat cake."

This quote, attributed to Marie Antoinette, is often held up as evidence of the disconnect between the wealthy and the lower classes at this time. Certainly the luxurious fashions associated with this era would not have been worn by the man (or woman) on the street.

NECKLACE

Necklaces were a key accessory, with popular styles including multistrand necklaces, simple pearl strings, and miniature cameos on necklaces or strung on ribbons. The Rococo aesthetic emphasized flowing lines and elaborate ornamentation.

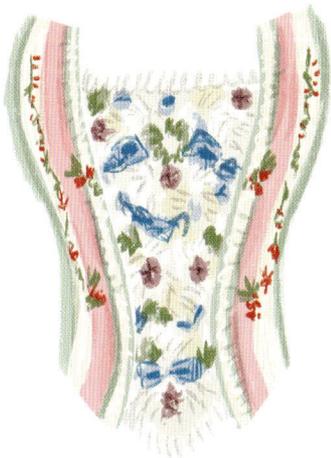

ALL FRONT

The front panel of a gown was called a "stomacher," and was often richly decorated with embroidery, ribbons, and lace.

FLOWER POWER

Natural motifs were the order of the day when it came to pattern, depicting flowers, leaves, shells, and sea creatures.

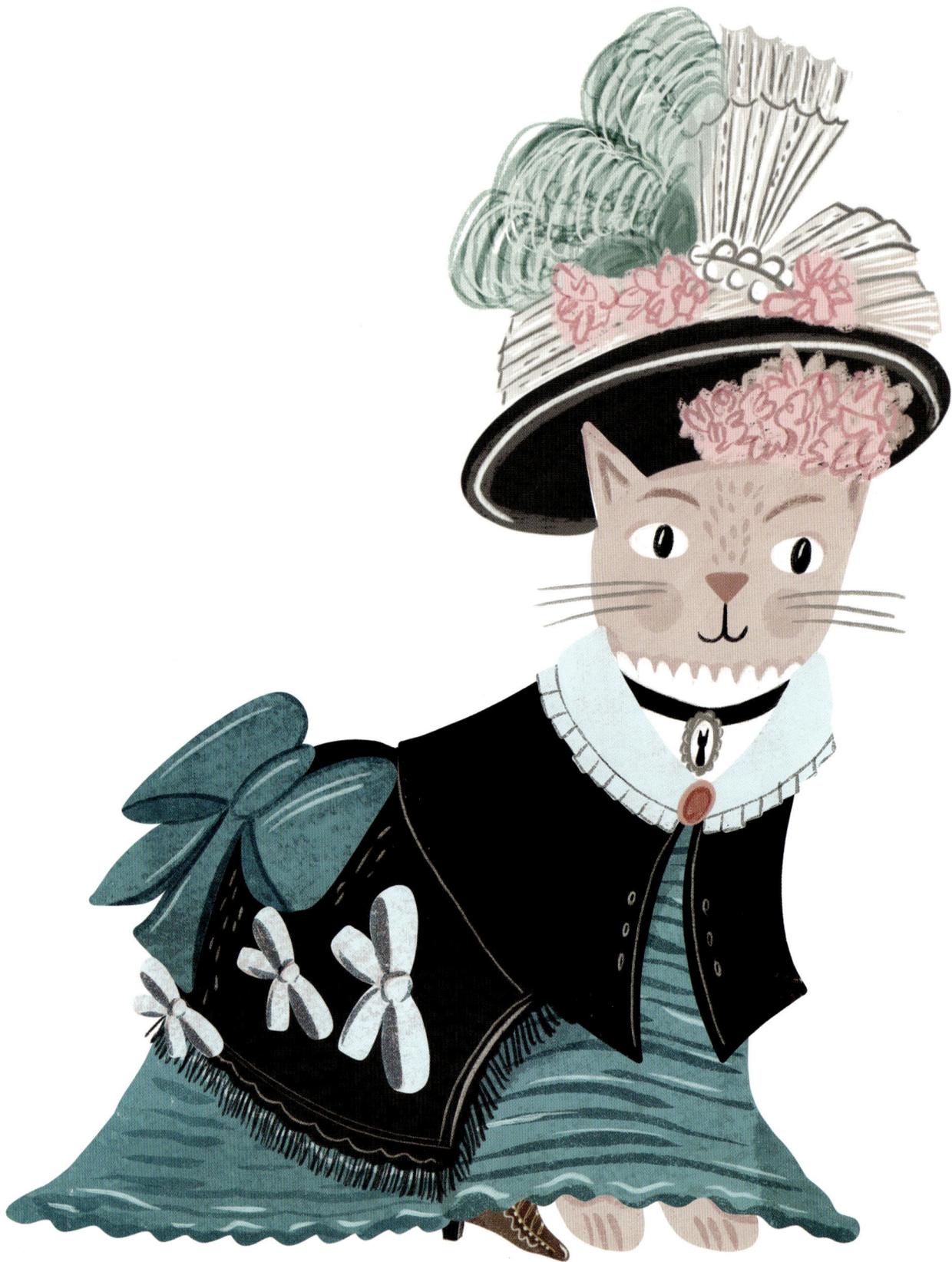

THE VICTORIAN CAT

Victorian fashion was a purrfect parade of frills, flounces, and formalwear. Spanning the reign of the British Queen Victoria from 1837-1901, this era saw silhouettes shift dramatically, with tight corsets, full skirts supported by crinolines, and high necklines. By the 1870s, crinolines had been replaced by bustles, which added volume to the back of the skirt. As the century went on, sleeves and skirts became narrower, and styles became more tailored.

Technological advances, such as the sewing machine and synthetic dyes, made fashion cheaper and therefore more accessible and varied. Fashion magazines helped spread trends quickly. While often restrictive, Victorian clothing also laid the groundwork for the more practical styles of the 20th century.

At a time when people were experiencing monumental shifts in societal structure and the cultural landscape, Victorian fashion, too, saw huge changes during the 64-year period. It might have been uncomfortable, but it was never boring.

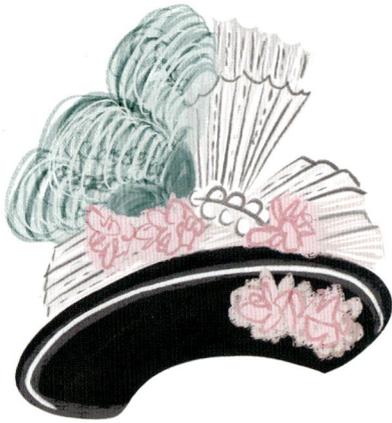

HAT

Felt was used for women's hats for the first time in the 1860s. Feather trims were often added, and flowers were used to decorate the front of the brim.

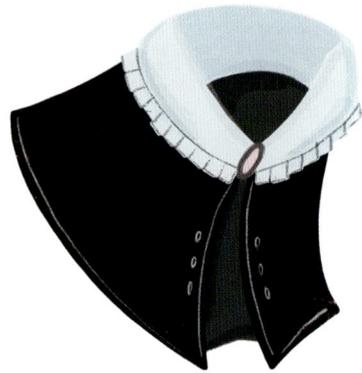

CAPE

With dress sleeves and crinolines too elaborate to be contained within a coat or jacket, the cape was a sleeveless overgarment that provided a practical and stylish solution.

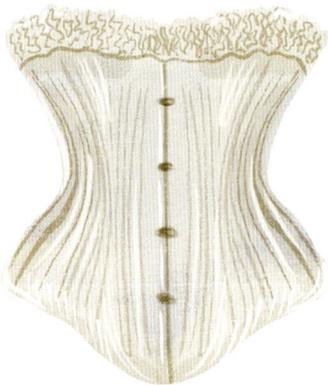

CORSET

With crinolettes making the waist look smaller, there was less need for the supertight, laced corsets of the previous decade. New methods of fastening and steam-molded corsets made it possible for women to dress themselves, making corsetry easier to manage for women without domestic help.

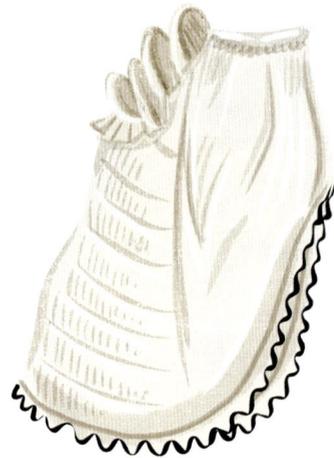

CRINOLETTE

Following on from the full, bell-shaped skirts of the 1860s, fashions moved toward volume at the back. So was born the crinolette, or half-crinoline. This modification kept a flat front to a dress, instead flaring out at the rear, exaggerating the posterior.

ALL THE TRIMMINGS

Tassels, bows, and trimmings were plentiful, adding a playful and decadent feel to dresses, which were made of rich materials such as silk, satin, and velvet.

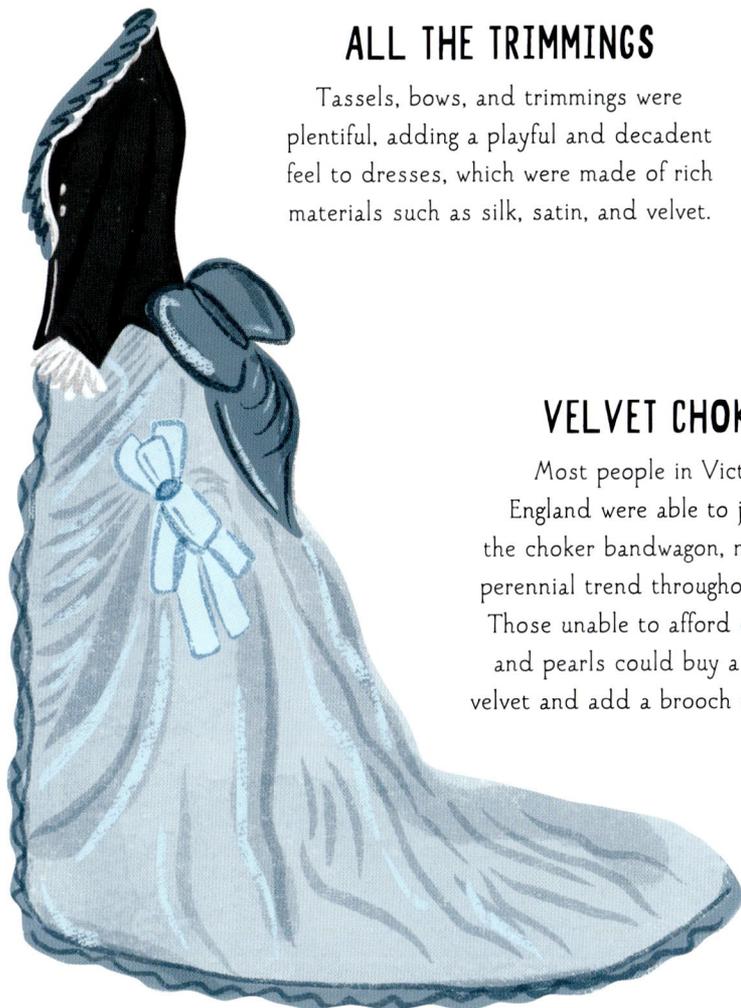

VELVET CHOKER

Most people in Victorian England were able to jump on the choker bandwagon, making it a perennial trend throughout the era. Those unable to afford diamonds and pearls could buy a length of velvet and add a brooch or pendant.

BOOTS

A mainstay of the wealthiest women in Victorian society, leather lace-up boots exuded opulence. They were often decorated with scalloped trims, fine embroidery, and lace detailing.

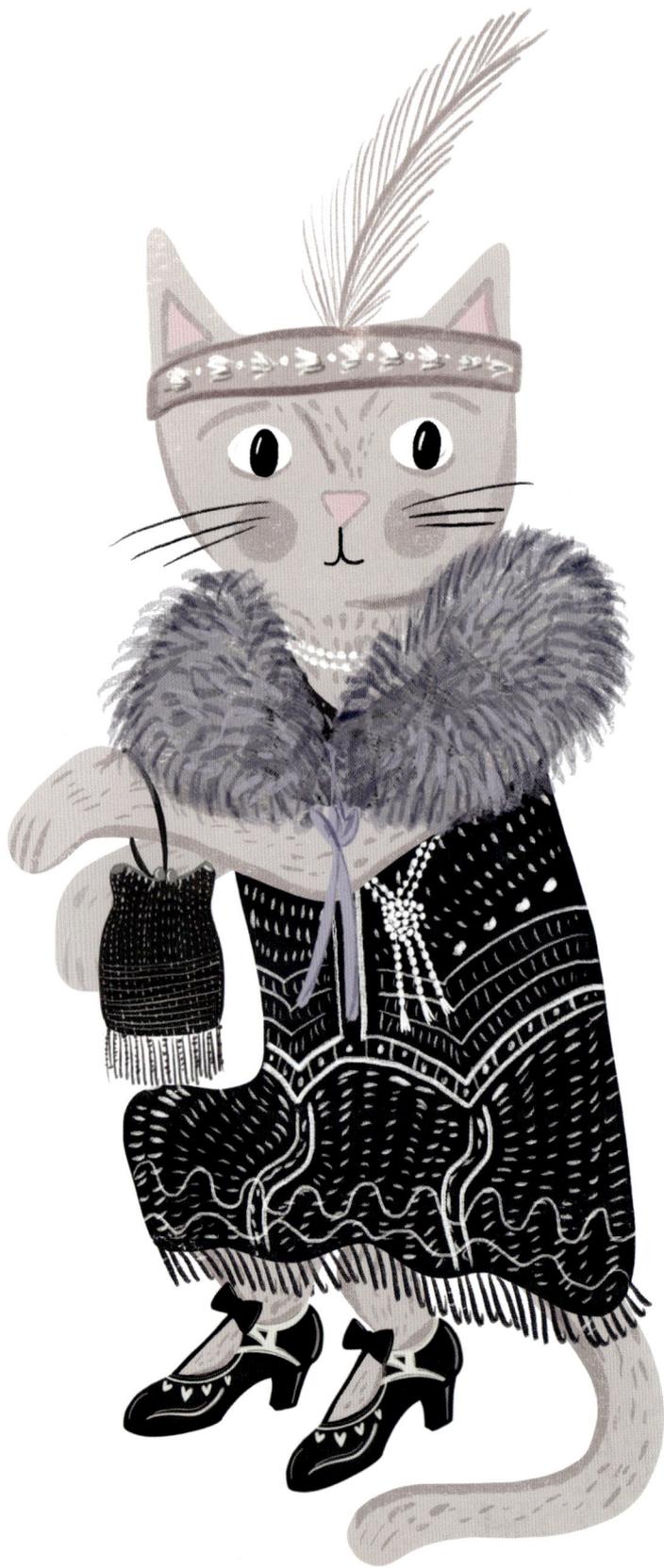

THE FLAPPER CAT

Forward-thinking, fashionable flappers were brave, bold, and revolutionary. Hot on the paws of the conservative Victorian and Edwardian eras, women in the 1920s weren't afraid to challenge gender norms and question their place in society. Rebelling against traditional social stereotypes, flappers pushed boundaries, in life as well as fashion. For this reason, their iconic sense of style lives on, even 100 years later.

A characteristic flapper outfit was a straight, sleeveless, knee-length dress. The shortness of the dress was especially shocking at the time. Stockings were rolled below the knee and a bobbed chin-length hairstyle set off a more androgynous silhouette. Makeup was bold, often featuring dark, dramatic eyes painted into a downward-slanting shape. Typical accessories included headbands, cloche hats, stacks of bangle bracelets, and long beaded strands.

This era of strong, independent women paved the way for generations of empowerment. The flappers' distinctive style came to define a generation of rule-breakers.

HEADWEAR

Women wore cloche hats in the daytime, and then swapped to headbands called *bandeaus* in the evenings. Inspired by ancient Egypt, precious stones, pearls, and feathers adorned hair clips, headbands, full headdresses, crowns, and tiaras.

EVENING BAG

Used more as stylish accessories than useful items, as they could only hold the essentials, handbags were petite and decorated with beads, just like the popular flapper dress.

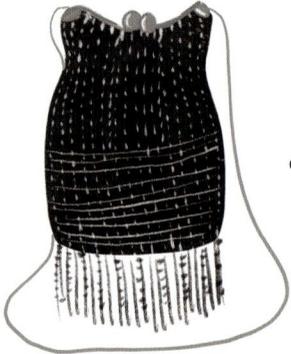

FEATHERS

Feathers were popular flapper accessories, featuring on headbands, hair clips, and in fans. Long feather boas were also worn to add a touch of extravagance and sophistication.

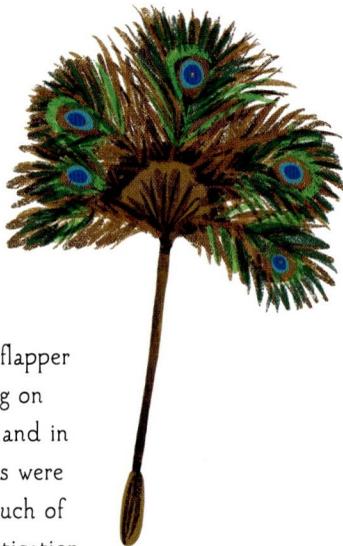

BEADED DRESS

Designer Edward Molyneux created this classic dress style that has become synonymous with the flapper era. He was revolutionary in using unusual patterns, as well as crystals and beads. His designs were popular among the wealthy and famous, such as stars like Greta Garbo.

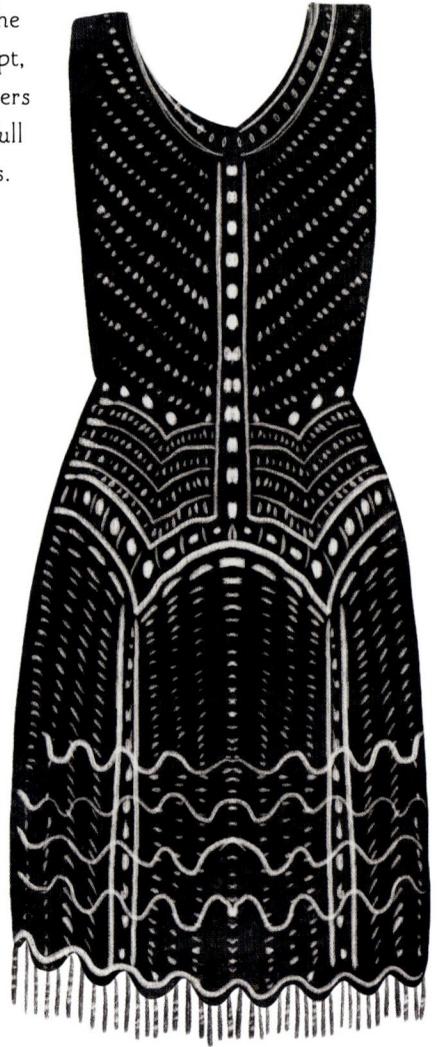

FUR STOLE

When an accessory needed to exude luxury and expense, fur was the top choice. From stoles and collars to wraps and shawls, both daytime and evening outfits were extravagantly elevated.

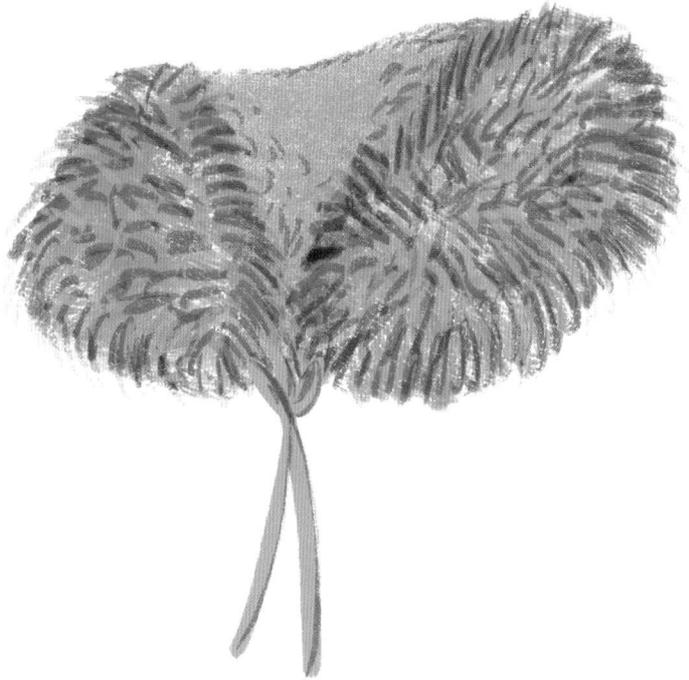

KNOTTED NECKLACE

The long pearl necklace is iconic of the 1920s. Women wore it as one strand, multiple strands of various lengths, and even cascading down the back. A tassel or a knot added interest.

Typical accessories included headbands, cloche hats, stacks of bangle bracelets, and long beaded strands.

DANCING SHOES

The ideal dancing shoe, flappers wore single-strap Mary Jane pumps or T-strap heels in plain black or painted in gold, silver, red, and white, occasionally embellished with crystals.

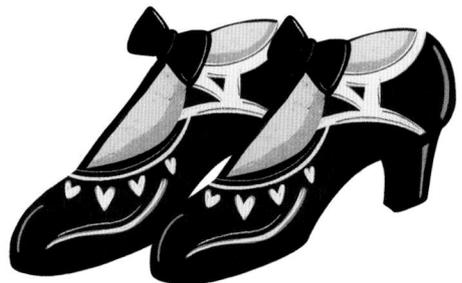

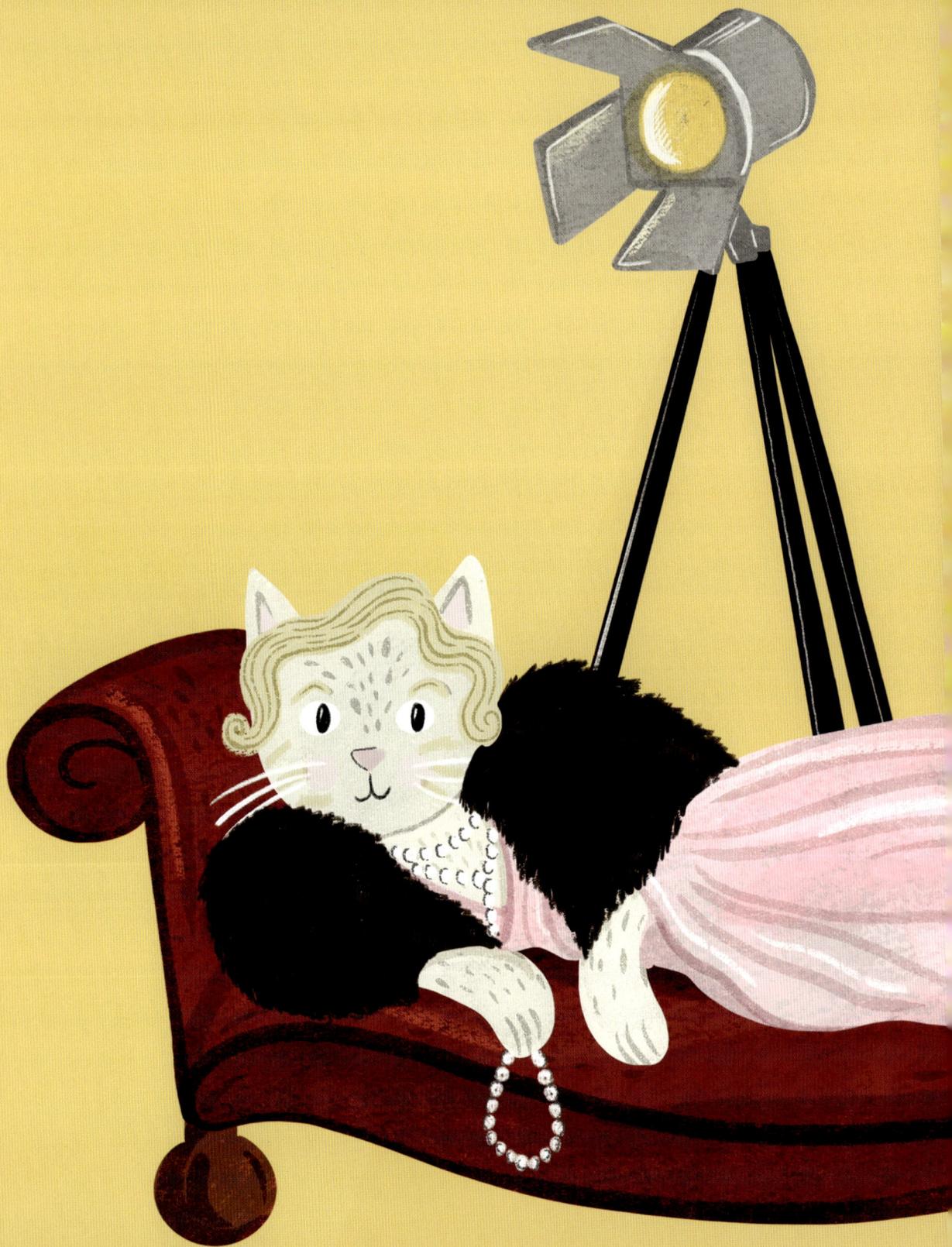

THE HOLLYWOOD GLAMOUR CAT

Hollywood sophistication and glamour shaped women's fashion in a big way in the 1930s. A golden age of style, women broke free of the restrictive undergarments of the turn of the century, as well as the boyish silhouette of the previous decade, and turned to the big screen for inspiration. In Hollywood, costume designers became almost as well known as the stars they dressed.

The glamorous fashions of this era provided much-needed escapism from the hardships of the Great Depression. Silhouettes were slinky, often Grecian-inspired and accessorized with berets, fur stoles, dramatic makeup looks, and wavy hair. The innovations of the era have lived on to this day, with bias-cut dresses, high-waisted pants, and A-line skirts as popular today as when they were debuted in this most elegant of decades.

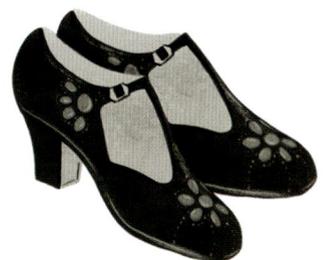

MAKING WAVES

Moving on from the sleek bobs of the 1920s, the 1930s were all about waves. Finger curls and pin waves with low side partings were inspired by screen stars such as Jean Harlow and Greta Garbo.

TOTALLY BIASED

Eveningwear took center stage and elegant, sensual gowns in silk and satin were designed to emphasize the shape of the wearer. Madeleine Vionnet was a pioneer of the bias cut, which saw fabric cut diagonally across the grain, and allowed her to create a uniquely fluid drape that was both figure-hugging and flattering.

Screen sirens such as Greta Garbo, Jean Harlow, Marlene Dietrich, and Joan Crawford set the tone for the era, which saw film stars become fashion icons.

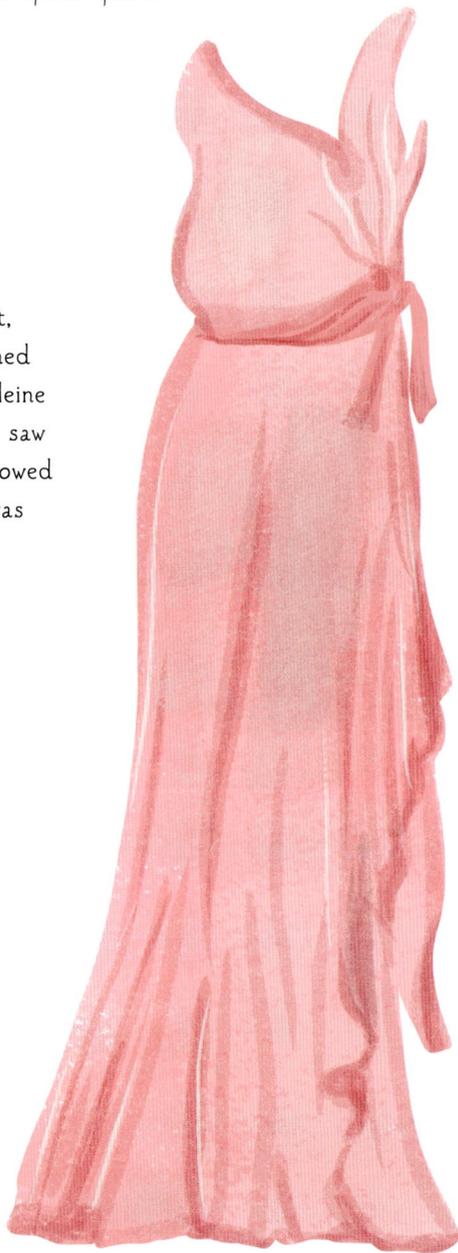

FUR STOLE

A striking fashion statement, as well as a practical accessory, in the 1930s no evening look was complete without a fur stole. A symbol of status and sophistication, these luxurious wraps were lined with satin and could be accessorized with ribbons and tassels.

STRINGS OF PEARLS

Long, layered pearl necklaces were popularized by style icons such as Coco Chanel. These versatile pieces could be worn both day and night. Fabulous Art Deco details with bold shapes and geometric elements often adorned the necklaces.

DOWN TO A "T"

The quintessential shoes of the 1930s, the T-bar was adorned with decorative perforations, designed to reveal the skin or a contrasting shade of leather underneath.

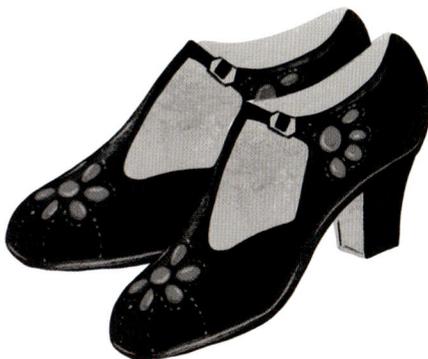

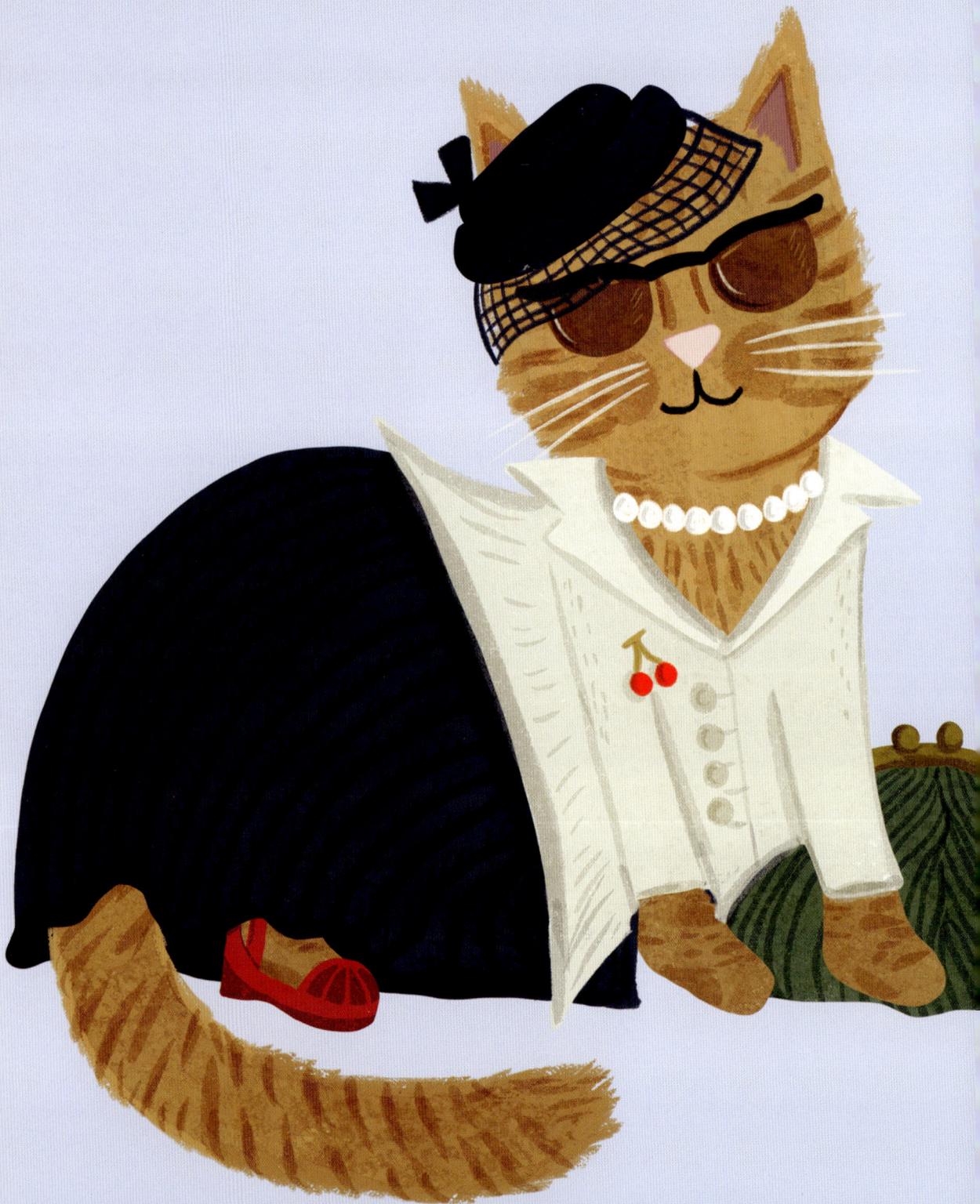

THE NEW LOOK CAT

You can't beat the chic of this 1940's cat. With the first half of the decade dominated by war, there had been little room for playfulness in dress. Both men and women were often in uniform, and even when they weren't, the availability of clothes was heavily dictated by rationing. However, the latter part of the decade kicked off a resurgence in creativity, with people keen to shake off the shackles of war and strut their stuff to celebrate their freedom, sartorial and otherwise.

French designer Christian Dior was instrumental in the movement toward a fresh approach. Launching what became known as the "New Look," his designs featured a characteristic silhouette with rounded shoulders, a nipped-in waist, and a voluminous skirt. This return to femininity and extravagance followed on from years of drudgery and was an utter revelation.

The new style celebrated the end of rationing and promised the return of glamour. Despite some criticism, the New Look continued to be "lapped up" well into the 1950s.

CAT'S EYES

In the 1940s, sun protection suddenly became fashionable! Plastic frames became available in many colors, including red, black, and yellow. This cat-eye shape appeared, but it was wider and rounder than the later 1950's design.

BEAD NECKLACE

Chunky, bakelite beads were a popular, yet inexpensive way to jazz up a plain outfit.

MON CHERI

Accessories inspired by fruit and vegetables, such as cherries, grapes, and bananas, were popular. Made from early plastics, these accessories were a quirky, inexpensive way to accentuate an outfit.

FULL SKIRT

The pleated design of the full skirt meant that it used many feet of fabric, which some people thought to be wasteful. There was also some concern that the skirt was overtly feminine, damaging the step toward greater equality that women had achieved during their wartime work. Nonetheless, the full skirt's popularity has endured to this very day.

PILLBOX HAT

Small, brimless, and round, the 1940's pillbox hat could be worn on the top, side, or back of the head. It sometimes had a small veil that fell over the eyes.

PLEATS PLEASE

The elegant shell- or scallop-shaped bag was a refined accessory for a special occasion.

"Even when there are no more secrets, fashion remains a mystery."

Christian Dior

THIN END OF THE WEDGE

The wedge shoe was a staple of 1940's fashion and loved by Hollywood icon Carmen Miranda. The shoe's thick sole and medium heel could be worn at both a casual catch-up and a more formal occasion.

WASP WAIST

With a nipped-in waist and structured shoulders, this collared jacket was a staple of the 1940's wardrobe.

Icons of the decade

Katharine Hepburn
Ingrid Bergman
Grace Kelly
Rita Hayworth
Doris Day

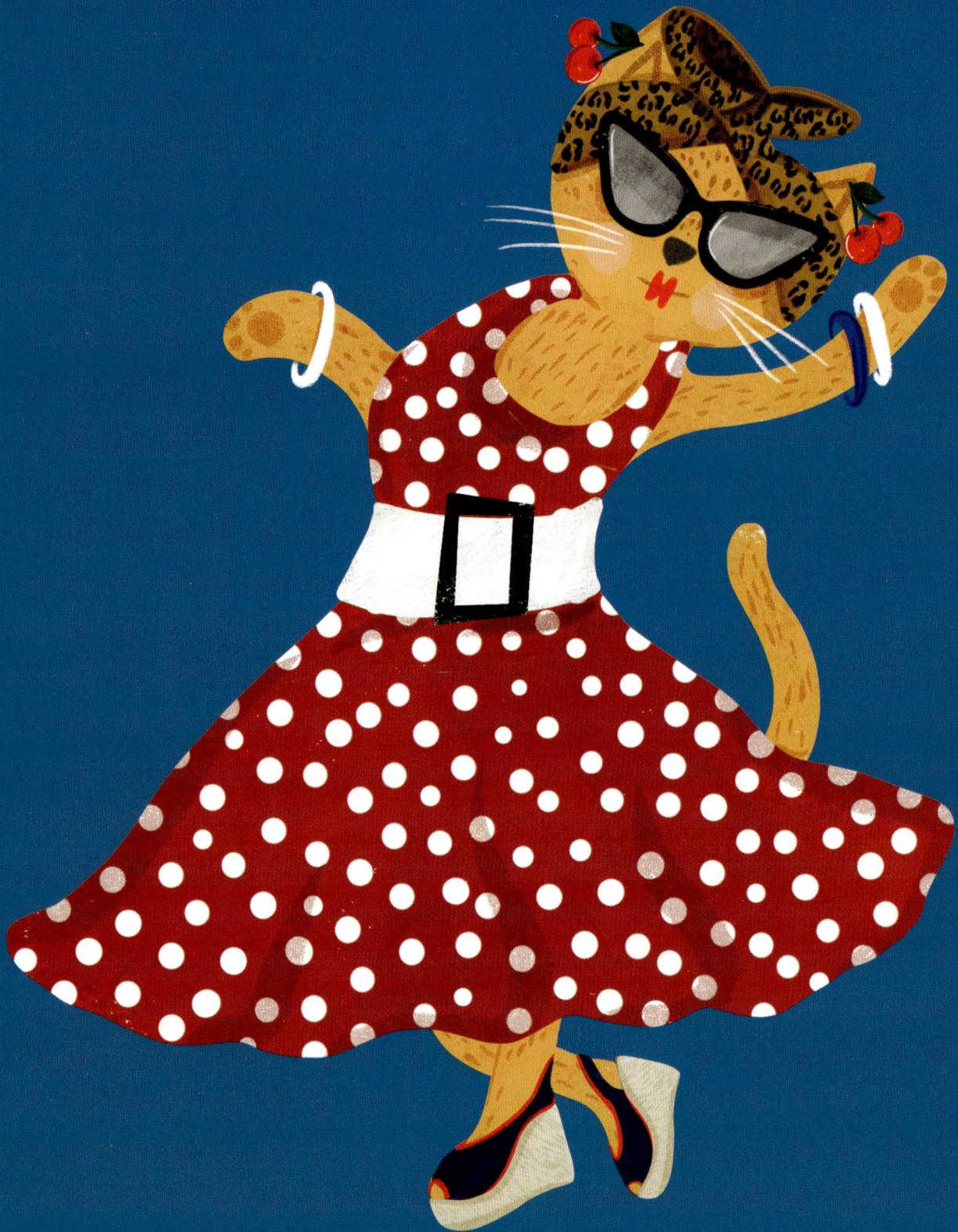

THE ROCKABILLY CAT

Much more than a fashion trend, rockabilly style emerged in the 1950s, a result of the explosion in popularity of rock and roll music in the USA. The term itself is an amalgamation of "rock" and "hillbilly" (a word used to describe country music)—it is impossible to separate the fashion from the music that inspired it. Combining a rebellious spirit with a glamorous, retro aesthetic, this distinctive style was favored predominantly by young people. They were keen to break free from the constraints imposed on the previous generation and shake a paw to a new rhythm.

Characterized by a stylish mix of elegant and daring, for men the look included leather jackets, skinny jeans, and slick, quiff hairstyles. For women, figure-hugging vintage dresses, flounced sleeves, polka dots, and cherry prints were the mainstays of the era.

In the 1970s and 1980s the style was given a facelift when it was adopted by punk and rockabilly revival bands.

Combining a rebellious spirit with a glamorous, retro aesthetic, this distinctive style was favored predominantly by young people.

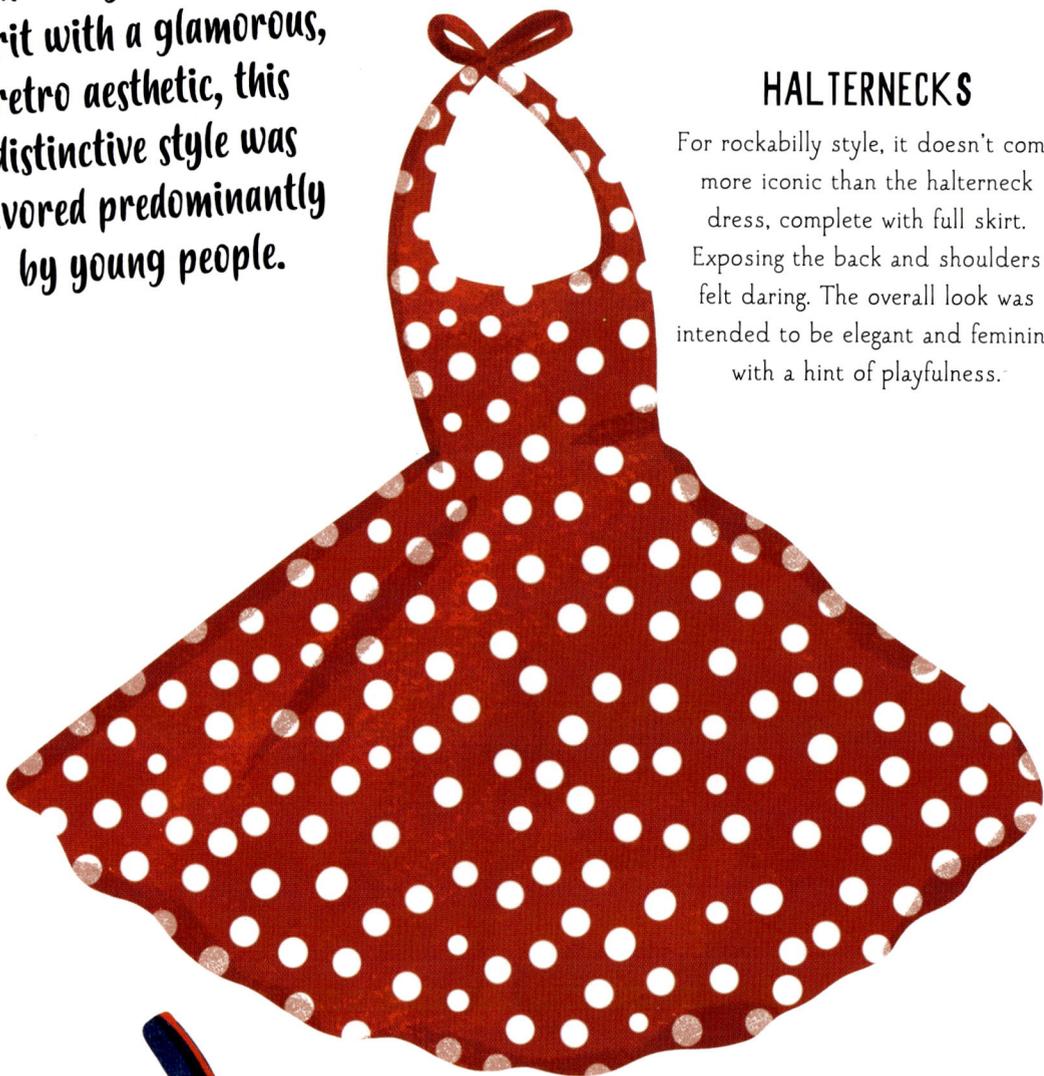

HALTERNECKS

For rockabilly style, it doesn't come more iconic than the halterneck dress, complete with full skirt. Exposing the back and shoulders felt daring. The overall look was intended to be elegant and feminine with a hint of playfulness.

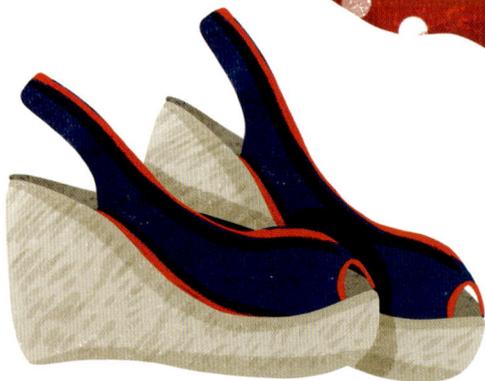

WEDGE SHOES

High yet comfortable, wedge shoes meant that the wearer could dance the night away while remaining at the cutting edge of fashion.

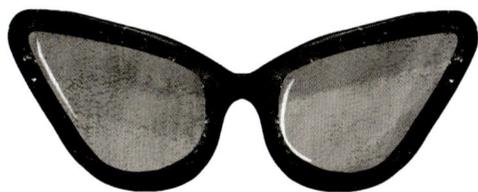

GLASSES

The 1950s saw the rise of cat-eye glasses as a fashionable accessory, with stars like Janet Leigh sporting the elegant frames. The glasses were slimmer and more pointed than the 1940's version, sometimes with fancy decorations.

HEADSCARF

Often worn tied around an updo hairstyle, the headscarf was a popular accessory and continues to be a mainstay of rockabilly style today.

CHERRY PRINT

Cherries, polka dots, and leopard print are commonly associated with the rockabilly era, although their popularity may have continued to increase in the decades since.

HELLO, SAILOR

A popular motif during the rockabilly revival of the 1970s and 1980s, the anchor symbolized a sense of adventure, independence, and rebellion.

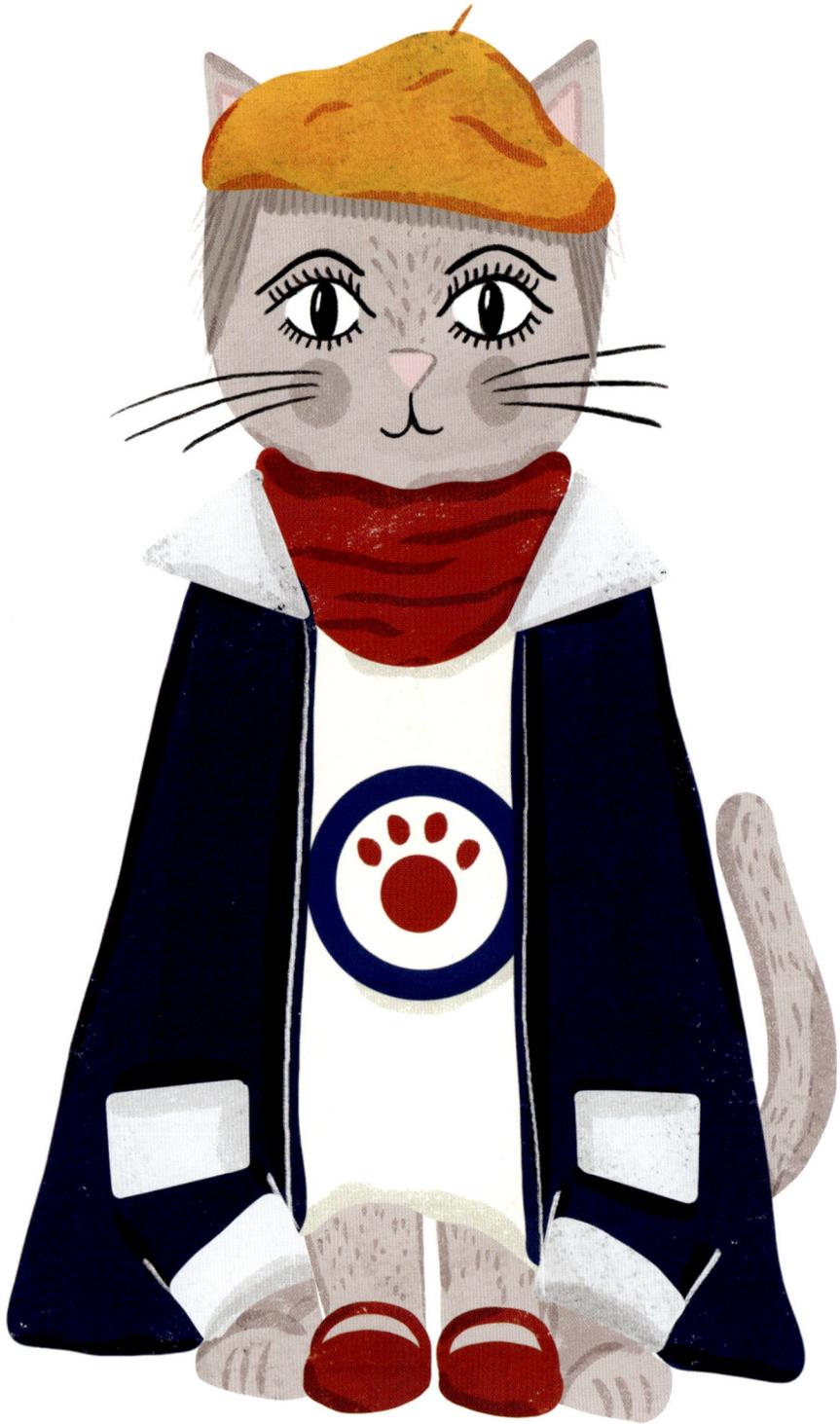

THE MOD CAT

The Mod-cat style started in the late 1950s in London, developing into its well-known look by the mid-1960s.

Mods had a completely unique fashion sense, wearing bright colors and bold patterns. Popular clothing at the time included mini skirts, shift dresses, tailored suits, and low-heeled go-go boots. British designer Mary Quant was at the forefront of the Mod trend and can be credited with popularizing the mini skirt, a fashion that excited some and scandalized others.

Mod style was closely tied to the popular music scene, with bands such as the Who, the Kinks, and the Small Faces inspiring fashionistas of the day with their sharply stylish looks. The Motown sound from the USA also influenced this youthful, dynamic movement.

NOTHING BEATS A BERET

Portraying a sophisticated, continental appearance, the beret was a favorite accessory of both men and women.

MOD MINI

Popularized by designer Mary Quant in "swinging" London, the mini was embraced by young women who appreciated Quant's playful, youthful designs. The mini craze caught on around the globe as designers tapped into its widespread appeal.

MARY JANES

Single-strap Mary Janes were often paired with bold tights, ankle socks, and short hemlines.

THE EYES HAVE IT

In Mod fashion, eyelashes were a key part of the look, with dramatic false eyelashes and heavily mascaraed, "spider" lashes being popular. Mod makeup generally focused on the eyes, with a minimalist approach elsewhere. The goal was to create a doe-eyed, childlike appearance, as exemplified by supermodel superstar of the day, Twiggy.

PVC COAT

In this era, new materials brought about a change in fashion. Women's clothing could now be made from acrylic, polyester, and PVC, as well as natural materials. Scientific advancements influenced designers Pierre Cardin and André Courrèges, who created styles inspired by space travel.

TURTLENECK

Both men and women sported turtlenecks, often in bright colors, layered underneath simple shift dresses or boldly patterned jackets.

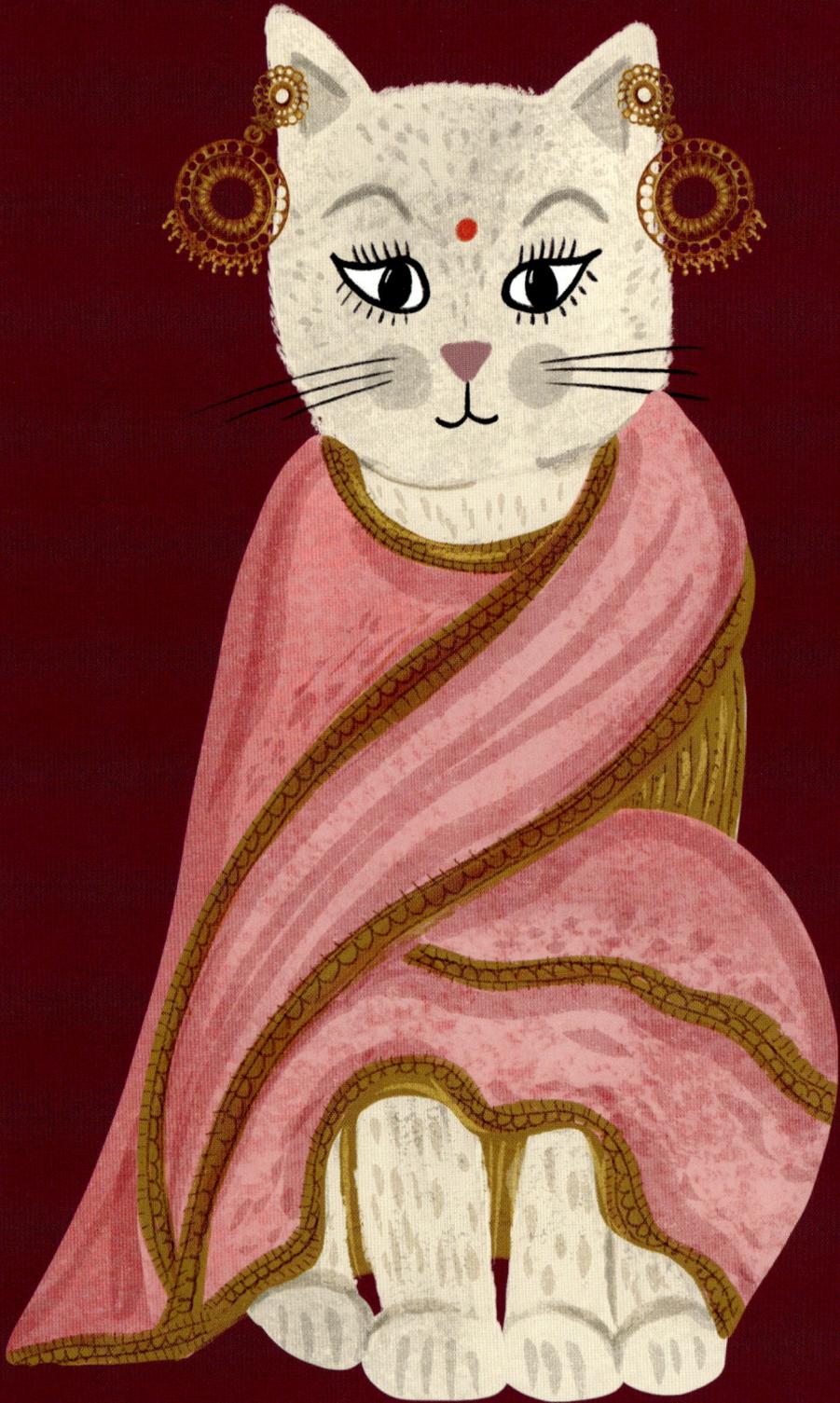

THE SAREE CAT

The saree, a staple of Indian fashion, can be traced back to the Indus Valley Civilization of 2800 BCE to 1800 BCE. Beginning life as a simple, untailored piece of clothing, draped around the body, it evolved through the centuries to become the fashionable and versatile garment that is still worn today.

The 1970s, in particular, brought a more experimental era for the saree. Bold prints, brighter colors, and non-standard drapes began to appear, especially influenced by global fashion trends. One instantly iconic style was the "Mumtaz" saree, made popular by actress Mumtaz in the film *Brahmachari*. It was tight fitting and bright orange in color, and married together traditional and modern elements.

During this era, the saree started to break free from its conventional image, especially with the introduction of synthetic fabrics like nylon and polyester. These fabrics made sarees more affordable, comfortable, and easier to maintain. Whether draped in a traditional style or given a more contemporary look, the new-style saree became a symbol of progress and youthful reinvention, while still respecting its rich heritage.

MAKE IT UP

The 1970s brought a strong eye game. From winged eyeliner to smoky kohl, the 1970s had it all and fashionistas rocked it with aplomb. Paired with otherwise minimal makeup and voluminous hair, it was a striking look.

SAREE STYLING

In the film *Brahmachari*, Bollywood star Mumtaz wore her saree in a new, tight-fitting way. This style became known as the "Mumtaz saree" and is still popular today.

The new-style saree became a symbol of progress and youthful reinvention, while still respecting its rich heritage.

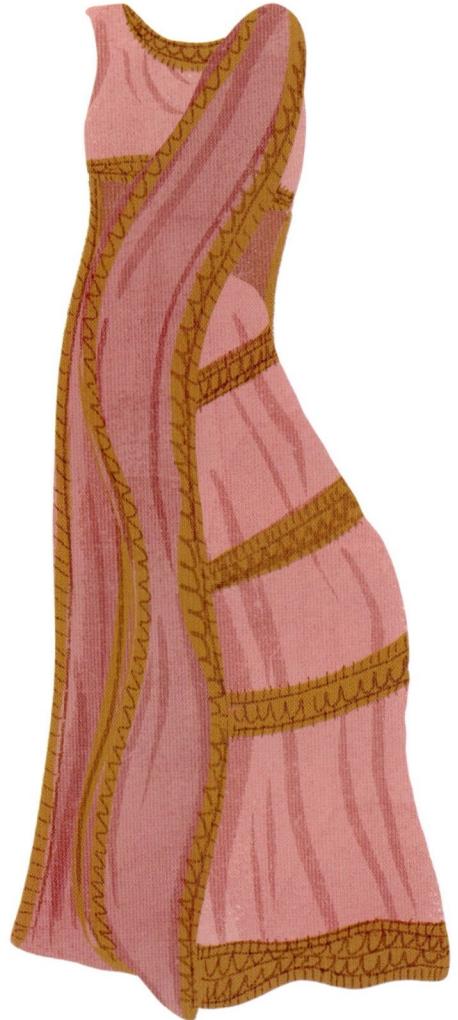

PRINTS AND PATTERNS

The fashion trends of 1970's Bollywood were influenced by both modern Western culture and traditional Indian styles. Bohemian prints and patterns became popular and were used to adorn floaty scarves that were worn by both men and women.

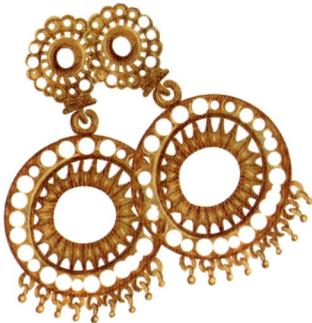

EARRINGS AND BANGLES

Traditional Indian jewelry has a rich history. Gold, in particular, has always been an essential embellishment, symbolizing prosperity and divinity. In the 1970s, traditional Indian gold jewelry, particularly bangles and oversized earrings, gained popularity, often incorporating motifs like peacocks and paisley.

Bollywood icons of the era

Zeenat Aman

Mumtaz Askari

Parveen Babi

Hema Malini

Rekha

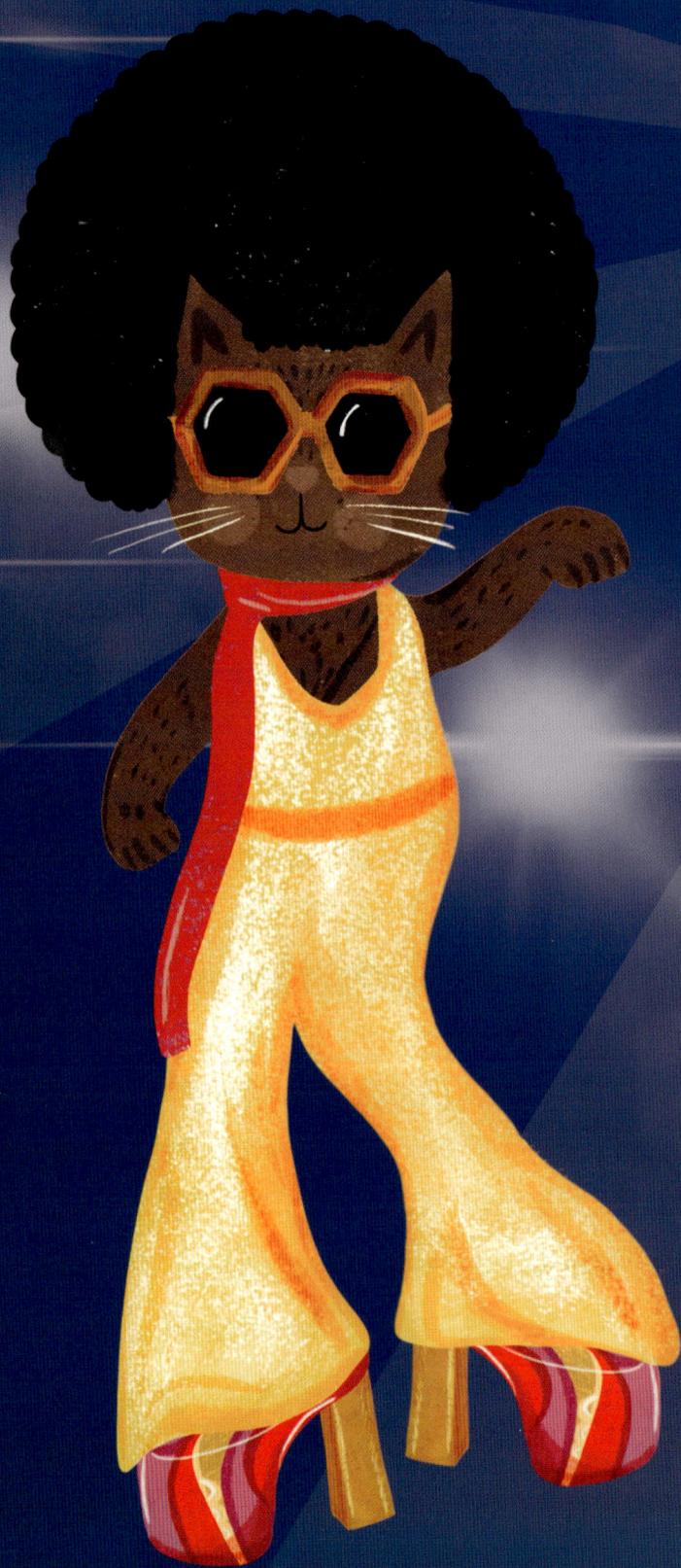

THE DISCO CAT

Synonymous with glitz, glamour, and fun, the disco era of the 1970s was a time of bold fashion—the flashier the better! Head-to-toe glitter was *de rigueur*, with disco kings and queens dressing to make a statement on the dancefloor. Flares ruled the scene, paired with colorful, fitted shirts with open collars for the men or slinky halterneck tops for women.

Sequins were everywhere, from mini skirts to jumpsuits, and towering platform shoes were a must, adding extra height and making everyone's dance moves a bit more outlandish. Men and women alike flaunted their style in shiny polyester, satin, and velvet, and coiffed their hair into fabulous, voluminous styles.

Inspired by the popularity of disco music, many iconic artists saw themselves rise to fame during this period. ABBA, Donna Summer, Gloria Gaynor, Chaka Khan, and Village People were popular influences during this time. The 1970s heralded an era when fashion and music became one, when every night out was a celebration of rhythm, fun, and fabulous outfits. An era that didn't take itself too seriously, it was a time when attention-grabbing style wasn't just accepted, it was encouraged.

DISCO BALL

Synonymous with the disco era, mirror balls first became popular in dance halls and ballrooms in the early part of the 20th century. In the 1970s, iconic venues such as Studio 54 and The Loft in New York City strung up their disco balls for their groovy clientele to strut their stuff beneath.

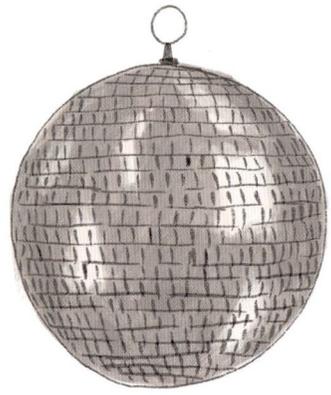

JUMPSUIT

Slinky and sophisticated, yet practical for dancing, the jumpsuit was a staple of disco-era fashion. The best loved were belted and shimmered with sequins or glitter.

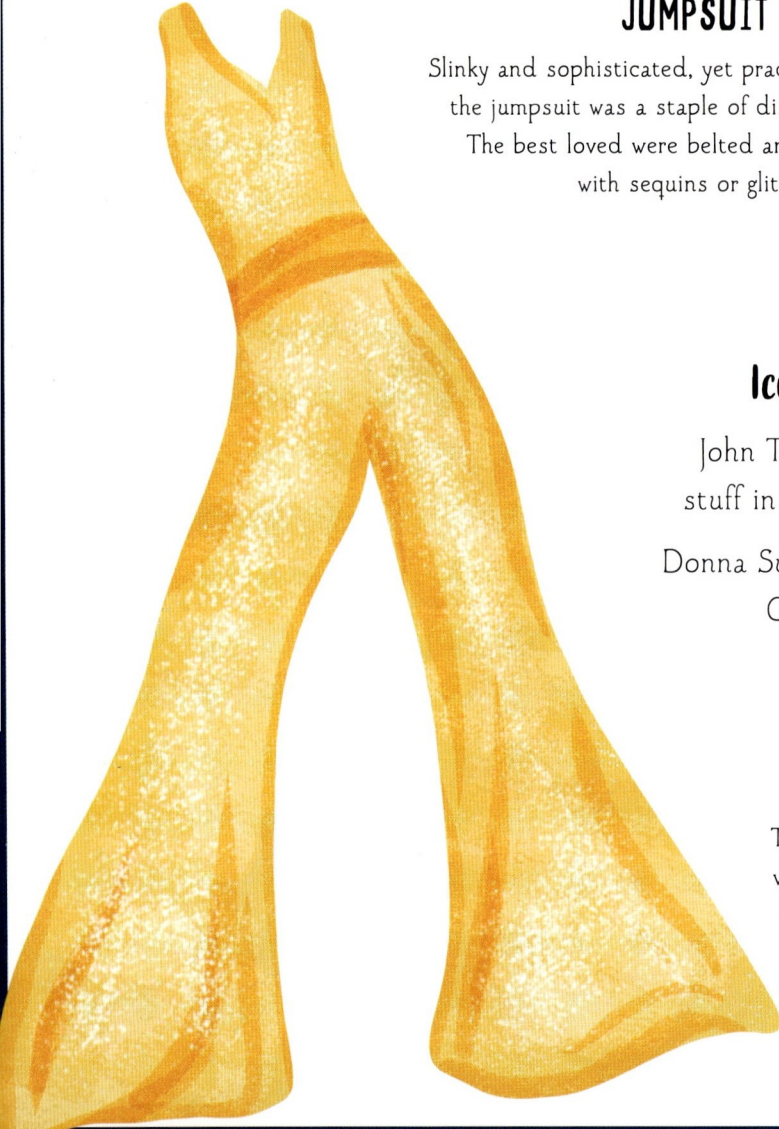

Icons of the era

John Travolta strutting his stuff in *Saturday Night Fever*

Donna Summer, the undisputed Queen of Disco!

FLARES

These pants flared from the knee into a very wide hem. No self-respecting disco diva would be seen with anything less than an epic flare.

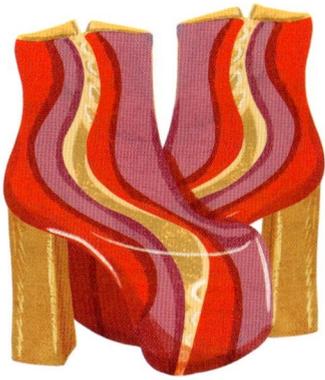

PLATFORMS

With an ultrathick sole that added height without raising the heel to an uncomfortable degree, platforms were the perfect party shoe and were worn by both men and women. A worldwide trend, these shoes were the perfect plus-one to dance the night away with.

SUNGLASSES

The 1970s saw sunglasses get much bigger. Oversized square frames were popular, worn by music star Elton John.

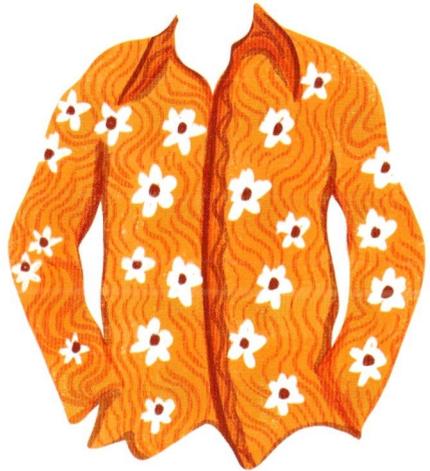

SEQUINS

Sparkle was key when it came to disco fashion. From metallic fabrics to sequins and glitter, both clothing and accessories had the glimmer treatment.

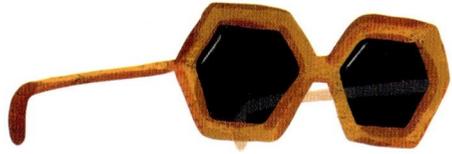

SHIRT

Disco fashion was all about floral designs, geometric shapes, and abstract prints. But the clothes stood for more than just style; they represented the movement and energy of the disco dancefloor.

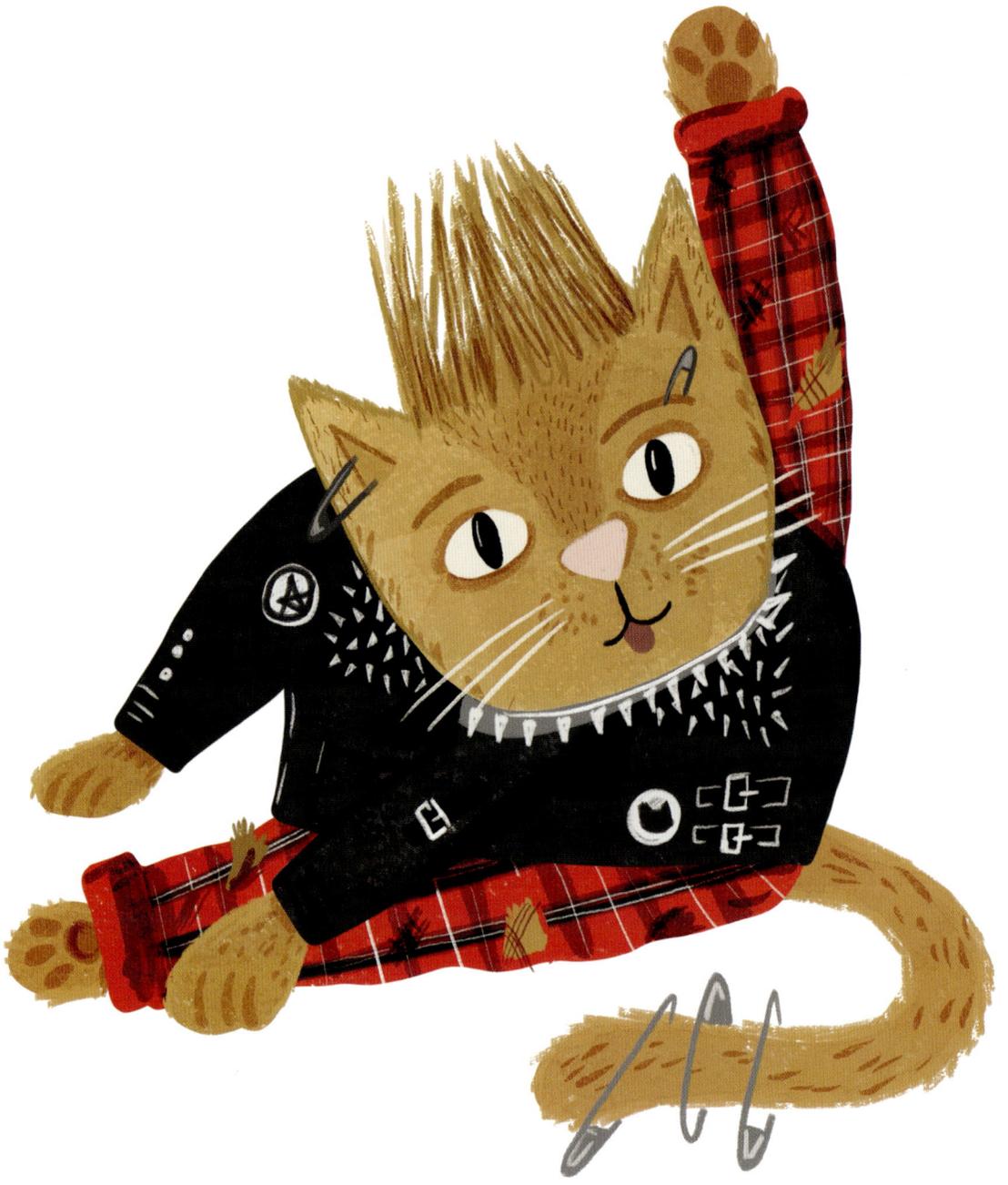

THE PUNK CAT

Nothing epitomizes the defiant, rebellious spirit of the 1970s and '80s like this proudly counter-cultural cat. Starting life as a powerfully anti-establishment music movement before spreading its influence to fashion and art, the punk era was a yowl against the status quo that would send shockwaves through the cultural landscape.

In stark contrast to the glossy and glamorous disco era that came before it, fashion choices in this period were typically intended to shock, and even offend, those with more mainstream tastes. The punk aesthetic, characterized by ripped jeans, leather jackets, band tees, and tartan, was more than a style; it was a statement. Designers such as Vivienne Westwood created avant-garde looks, with embellishments such as spikes, chains, and safety pins the tip of the outrageous iceberg.

Punk fashion was much more than a fleeting trend; it was a powerful statement of identity, resistance, and self-expression. Its influence is still felt today—challenging the norms, breaking barriers, and leaving a legacy of creativity and rebellion that continues to inspire

MOHAWK

Punk hairstyles rejected conventional beauty standards and were all about uniqueness. Spiky, colorful, and eye-catching, the mohawk could be achieved using sugar and water solutions, gelatin, and even white glue!

STUDDED COLLAR

A classic punk fashion statement, the studded collar was a declaration of intent. Edgy and easily customized to the wearer's taste, studded collars were small but powerful symbols of non-conformity and individuality.

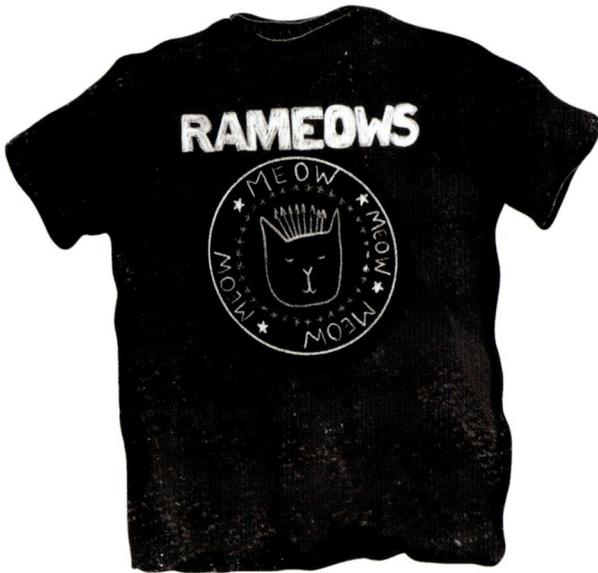

I'M WITH THE BAND

Band T-shirts were at the center of punk fashion. Wearing them showed an allegiance to the punk movement and its music, showcasing both individuality and community all at once.

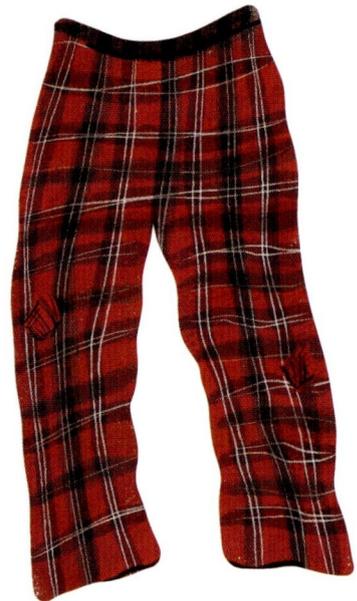

CHEQUERED HISTORY

Thanks to Vivienne Westwood, tartan became a symbol of rebellion in punk fashion. The designer sometimes used a mixture of tartans in a single garment—a bold style that symbolized defiance, and went against the grain of fashion norms.

LEATHER JACKET

Leather became a symbol of the rebellious spirit of punk. Jackets were the most common leather garment, but it was also used for accessories. Wearing garments in such an eye-catching material allowed punk followers to rally against society's conventions.

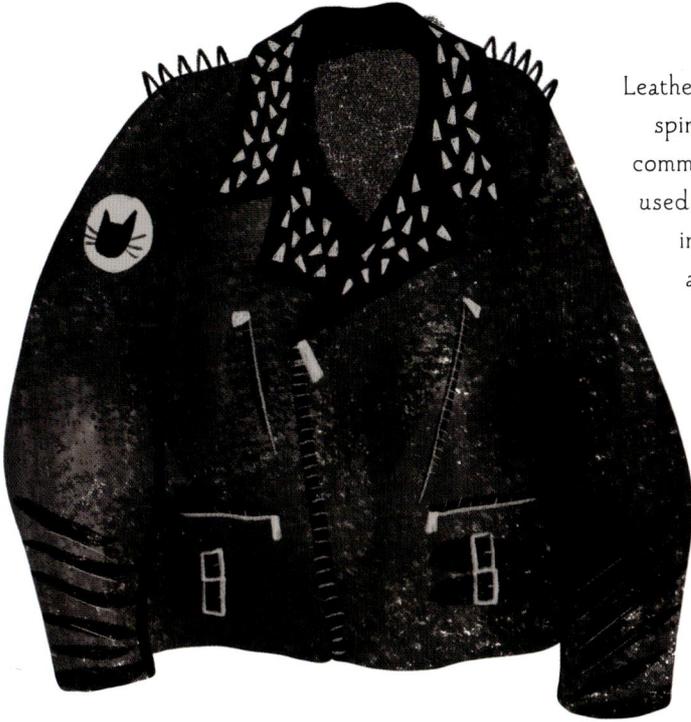

GUITAR

It is impossible to separate punk fashion from punk music. In mid-1970's New York and London, bands like the Ramones, the Sex Pistols, and the Clash performed short, snappy songs. Often their song lyrics would be laced with social and political commentary.

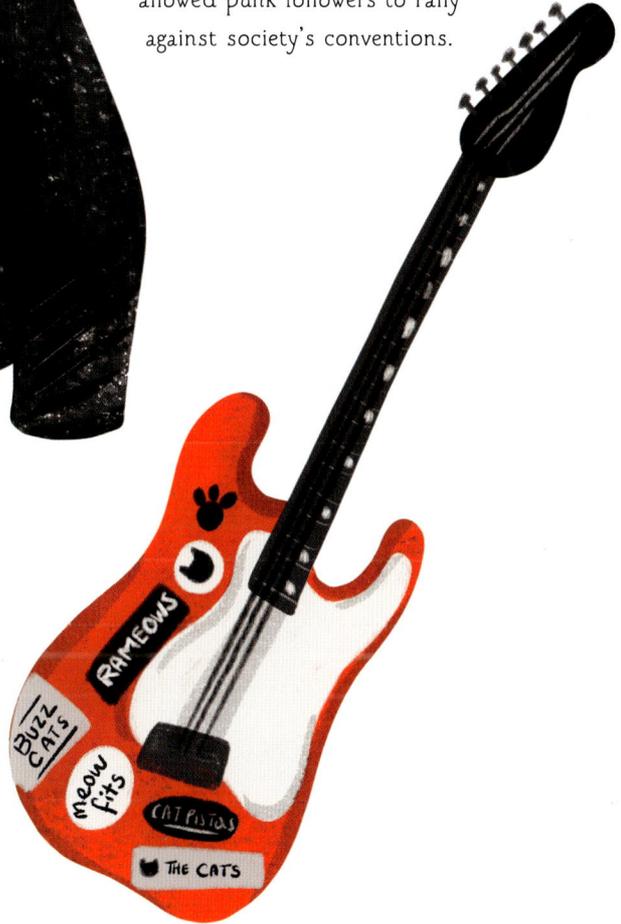

STICK A PIN IN IT

A common household item, punks turned the safety pin into an emblem of their movement. Popping up as hair accessories, facial piercings, and used to create custom clothing designs, no punk outfit was complete without a handful of safety pins.

THE HARAJUKU CAT

Harajuku style originated in the 1980s and 1990s as a blend of various subcultures, characterized by bold, exaggerated fashion choices that blended traditional, punk, and pop-culture influences. Known as the ultimate fashion playground, the Harajuku district of Tokyo experienced an explosion of eclecticism and individuality. It was driven in part by a rebellion against Japan's relatively strict societal rules as well as by the influx of Western culture after World War II.

This introduction of Western culture had a lasting impact on the local youth, who began to experiment with fashion and music. The first wave of Harajuku style in the 1980s was all about fun, frivolity, and freedom. Harajuku encompassed a broad range of styles, with punk-inspired looks featuring leather jackets, ripped jeans, and bold graphic tees, and kawaii styles plumping for pastels, polka dots, and bows. Playful accessories, such as animal ears, were also synonymous with the Harajuku style.

Harajuku fashion wasn't about following trends, but it represented a newfound freedom of expression and liberated sense of fun.

HAIR ACCESSORIES

Hair accessories played a key part in the Harajuku look, particularly in the *decora* style, which was inspired by 1980's cartoon characters such as Strawberry Shortcake, Hello Kitty, and Pokémon. Large quantities of colorful plastic hair accessories were worn at the same time, often almost covering the hair completely.

OVERSIZED BOWS

The wild, cartoonish accessories continued with enormous bows, worn alongside vibrant hair accessories. The Lolita style is most commonly associated with this type of adornment.

JEWELRY

The cutesy accessories didn't stop at hair clips—bright, inexpensive bracelets were piled high up the arms—the more, the better!

SKIRT

Particularly popular in the *kogal* and *kogyaru* styles, which center around Japanese high-school uniforms with a fashionable twist—short skirts are a common feature of Harajuku style. Knee-high or thigh-high socks are often worn, either pulled up or rolled down. The *decora* style, too, includes tutu-like skirts worn with plain shirts and sweaters.

LEGWARMERS

Characters in Japanese anime and manga (animations and graphic novels) are often depicted wearing legwarmers. This trend quickly moved from the screen to the streets, inspiring Harajuku fashion enthusiasts to incorporate legwarmers into their own unique looks.

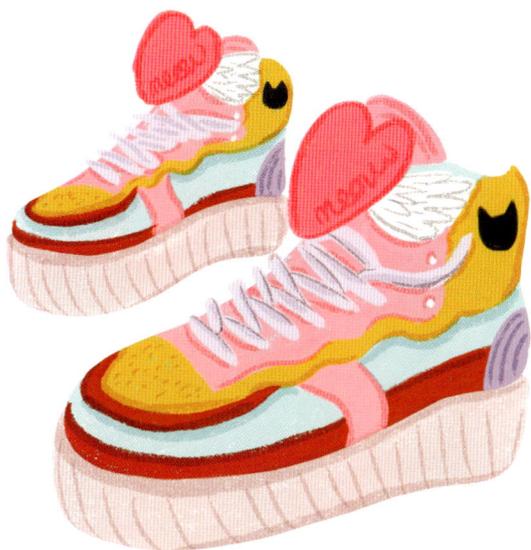

BEST FOOT FORWARD

Footwear varied depending on the influence—from punk biker boots to platform-soled sneakers. As ever, the more extreme, the better!

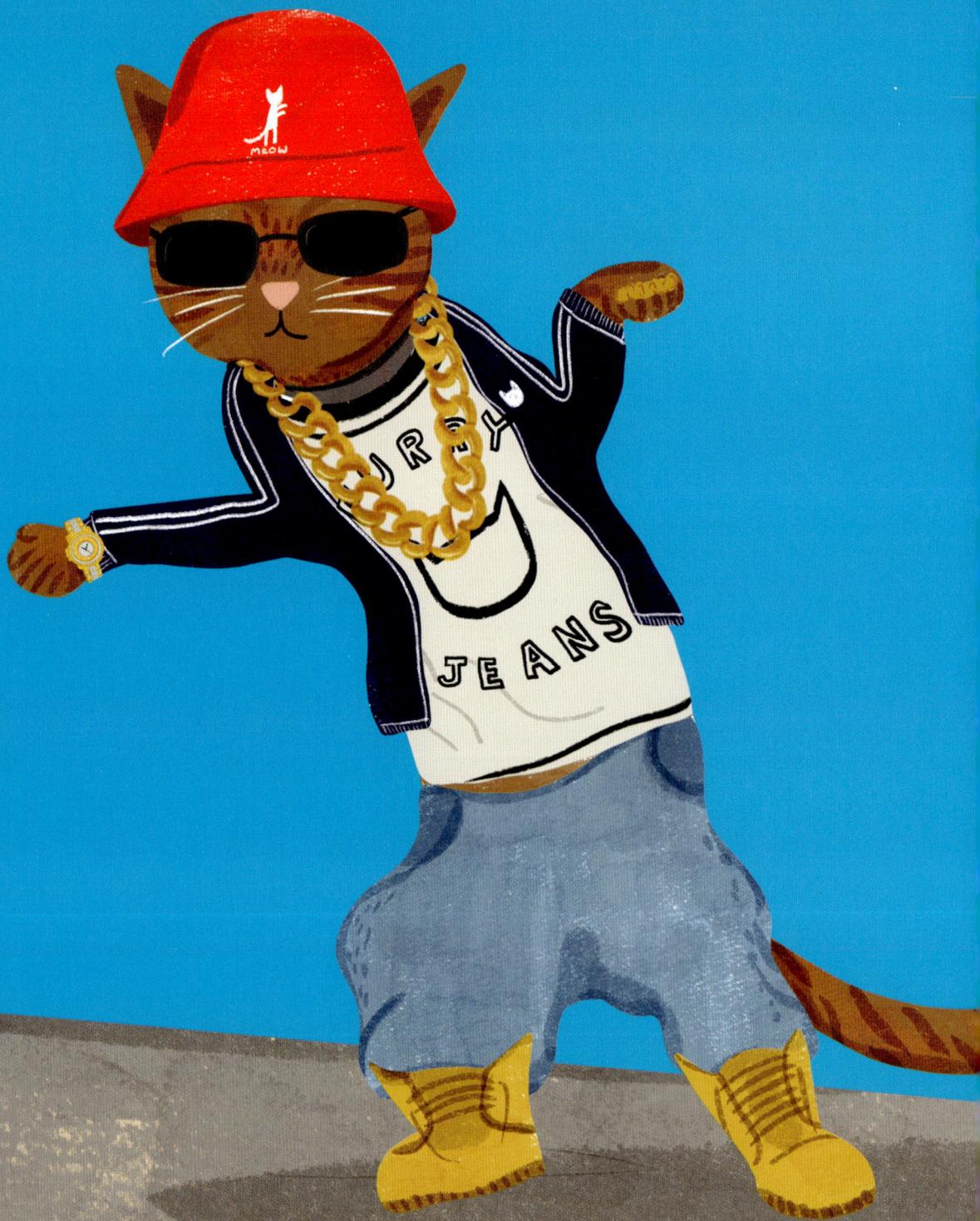

THE HIP-HOP CAT

The ultimate blend of street style, luxury, and personality, the fashion of the hip-hop era took off in the late 1970s before exploding in the 1980s and 1990s. The look was quite literally larger-than-life, from oversized pants, worn low, to huge jackets. Rappers and hip-hop stars weren't just influencing music; they were style icons who set the trends for a generation.

Tracksuits from popular sports brands were a must-have, often paired with chunky gold chains and oversized watches. Sneakers, particularly, became a fashion phenomenon, worn as much for style as for comfort. Fitted caps, bucket hats, and bandanas were key accessories, each adding unique flair to an outfit. Jewelry was another major component—the blingier the better. As well as looking flashy, these accessories signified success and confidence. Hoodies, bomber jackets, and graphic T-shirts with bold logos or cultural references made a lasting impact on streetwear.

Hip-hop fashion was more than just clothes—it was a lifestyle, a way to show pride, authenticity, and individuality. This bold blend of the luxury and the everyday proved iconic and continues to influence fashion, from the catwalk to the street, today.

HEAD GEAR

American rapper LL Cool J adopted the "B-boy" style, wearing bucket hats, gold jewelry, baggy clothes, and branded sports shoes. The B-boy style originally came from the street dancers of New York, who wore comfy clothes when they were breakdancing during the instrumental parts of a song.

GLASSES

The 1980's hip-hop scene popularized oversized glasses—particularly from the brand CAZAL—for everyday wear. Well-known hip-hop stars such as Darryl McDaniels from Run-DMC and the Fat Boys brought the look into the mainstream.

SPORTS FANS

Hip-hop fashion was about breaking the style rules, and no one did it better than Run-DMC when they wore their casual sportswear clothing during concerts—something that had never been done before.

SPORTS JACKETS

When sports brand Nike started working with NBA star Michael Jordan, it became one of the most influential collaborations in sports history, launching both brands into the stratosphere! This move kicked off a slew of collabs, including between Run-DMC and Adidas.

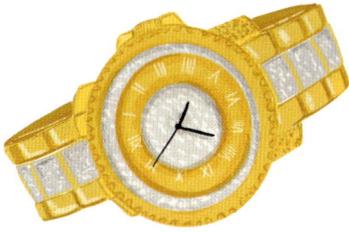

BLING

Thick, ropelike chains and medallions became popular in the 1980s and '90s, influenced by the style of Run-DMC and LL Cool J. The jewelry was so over-the-top and eye-catching to signify wealth and success, an important social statement after years of Black suppression throughout history.

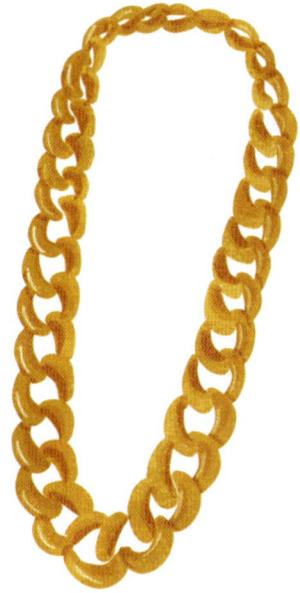

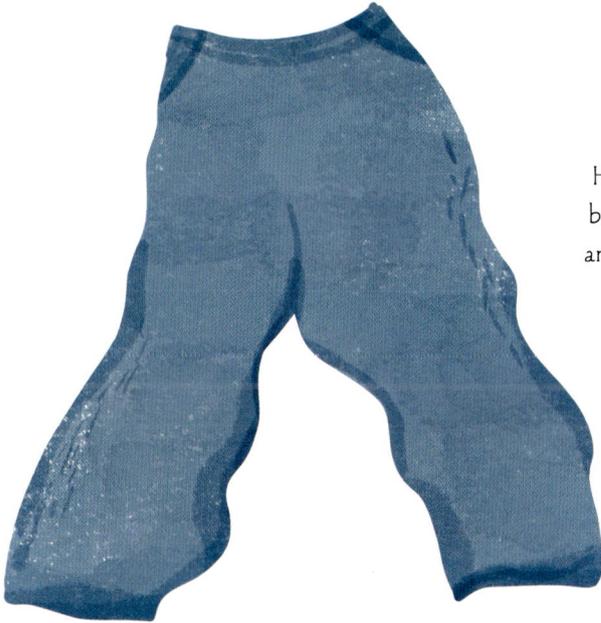

BAGGY PANTS

Hip-hop artists in the 1990s tended to wear baggy clothes because they were comfortable and expressed individuality. It's also thought that bagginess was a statement about the prevalence of hand-me-downs in marginalized groups where financial hardship was more likely.

WORK BOOTS

Primarily the top choice for 1990's construction workers, these hard-wearing boots were also loved by hip-hop artists. The boots were tough and unforgiving—a look that hip-hop artists wanted to emulate.

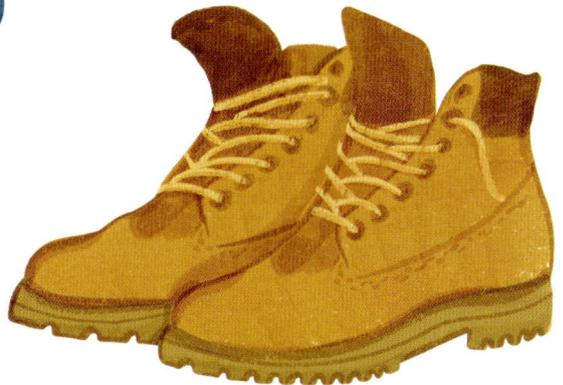

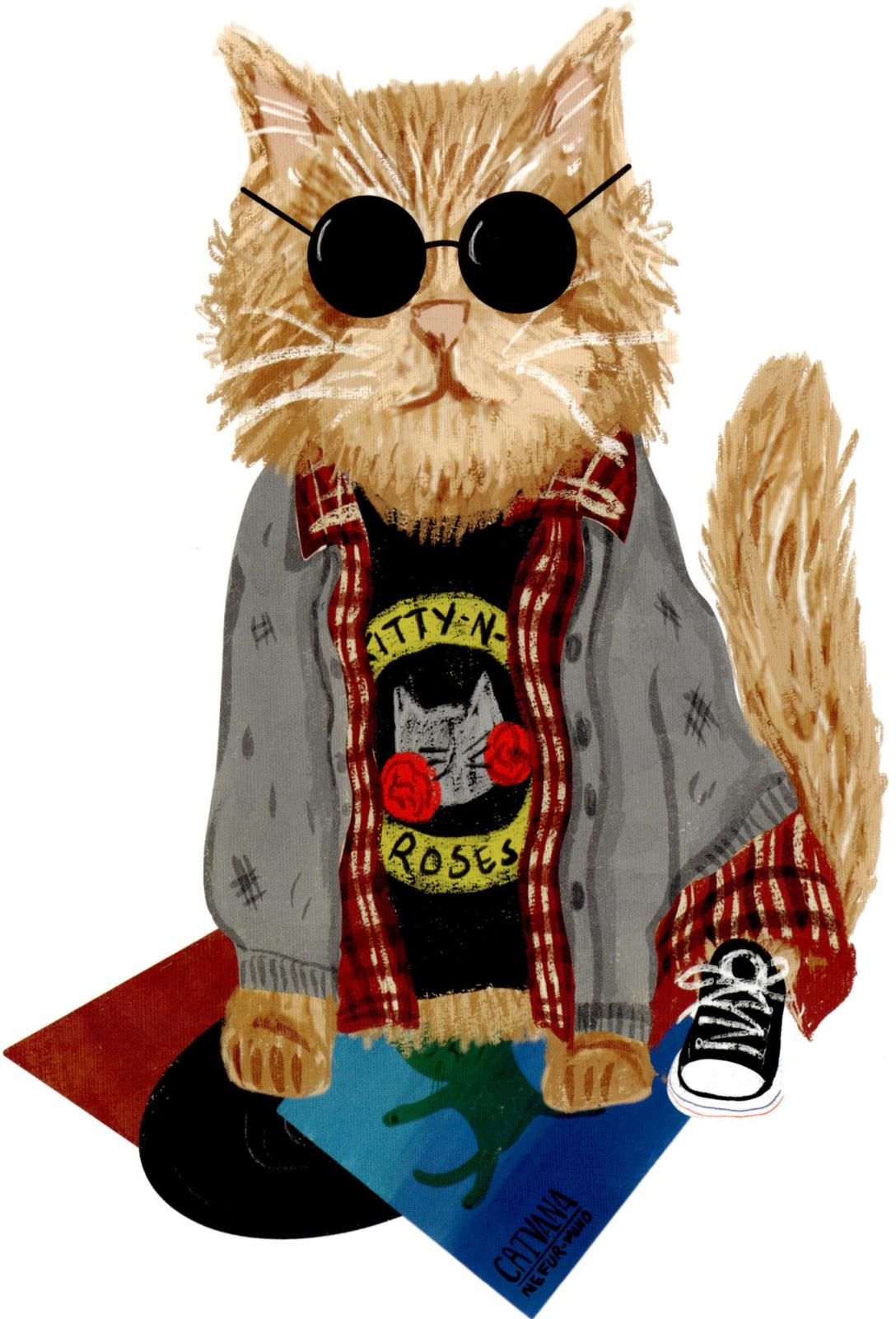

THE GRUNGE CAT

In a kickback against the flashy, glamorous looks that dominated fashions of the 1980s, the grunge era embraced a more rebellious aesthetic. Fashion in this era was inspired by the Seattle music scene, with bands like Nirvana and Pearl Jam leading the charge. The look was messy, unkempt, and laid-back, with a marked nonchalance.

Flannel shirts were a signature piece, often worn tied around the waist and paired with ripped jeans or denim jackets. The style screamed comfort, with oversized, loose-fitting clothes replacing the tight, body-conscious styles of previous decades. High-top sneakers and heavy boots were staples and helped to add a tough, rebellious edge to any outfit.

Grunge fashion loved layers. Shirts worn over T-shirts, sweaters over long-sleeved shirts, and plenty of mismatched accessories were commonplace. Grunge style wasn't about being perfectly put together but rather about looking effortlessly cool and embracing imperfections. Makeup was minimal, with smudged eyeliner often adding to the dishevelled, punk-inspired look.

A statement against consumerism and societal norms, grunge fashion confidently positioned itself as above and beyond fashion.

PLAID IS KING

Oversized flannel shirts, often in plaid pattern, were a prominent part of grunge style. A flag bearer for the rejection of glamour, Nirvana's Kurt Cobain was a famous flannel-wearing grunge icon.

LAYER UP

Grunge fashion promoted layering, whether it was with multiple tops, jackets, shirts, or cardigans.

GLASSES

Circular or oval glasses with thin, metal frames were essential armor for any self-respecting grunge-ista.

HIGH-TOP SNEAKERS

The simple, canvas design of high-top sneakers aligned with the grunge aesthetic's focus on comfort and practicality, rather than flashy or trendy footwear.

GET IT **ON RECORD**

Big names in grunge music, such as Nirvana and Pearl Jam, heavily influenced fashion at the time. Fans not only wanted to show their allegiance to the music, but also copy the style to look just like their favorite grunge artist.

CATVANA
NEFUR-MIND

KITTY-N-
ROSES

BAND TEES

Grunge music was extremely meaningful to its fans, so band T-shirts and merchandise became an important symbol of who you were and what you believed in.

TIMELINE

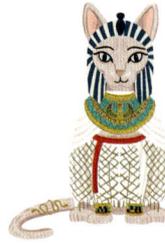

3000-330 BCE
Ancient Egyptian

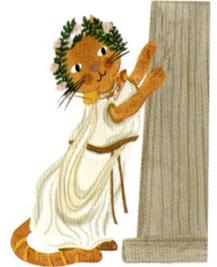

1200-323 BCE
Ancient Greek

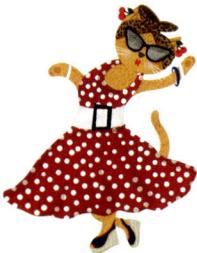

1950s
Rockabilly

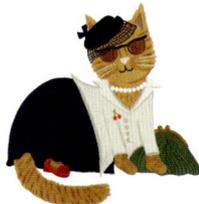

1940s
New Look

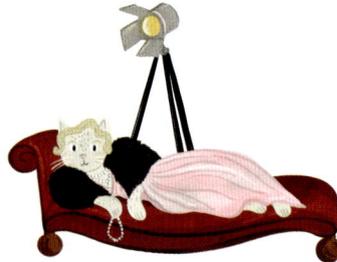

1930s
Hollywood Glamour

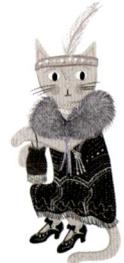

1920s
Flapper

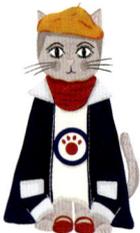

1960s
Mod

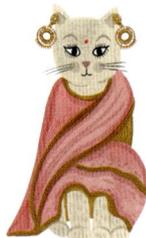

1970s
Saree

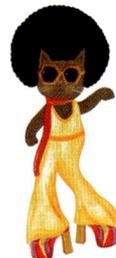

1970s
Disco

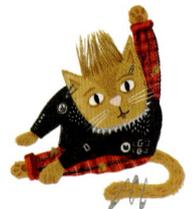

1970s-1980s
Punk

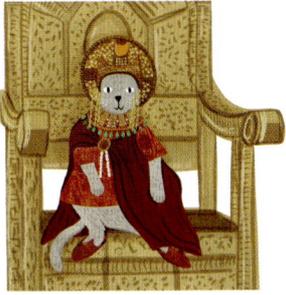

395-1453

Byzantine

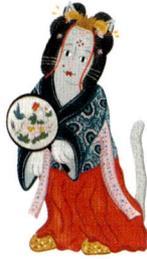

618-907

Tang Dynasty

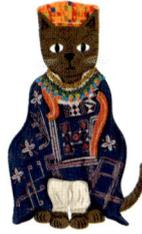

8TH CENTURY

Early African

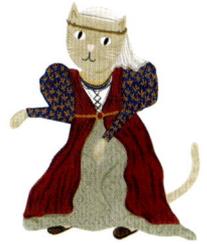

15TH CENTURY

Quattrocento

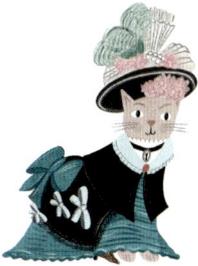

19TH CENTURY

Victorian

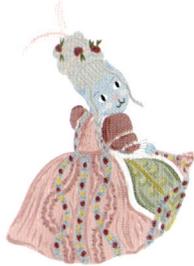

18TH CENTURY

Rococo

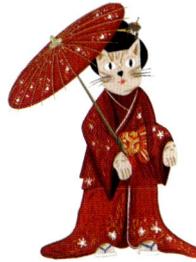

17TH-19TH CENTURY

Edo

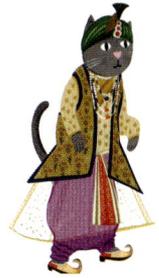

16TH-18TH CENTURY

Mughal

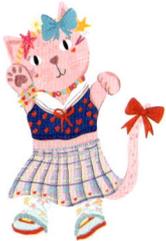

1980s-1990s

Harajuku

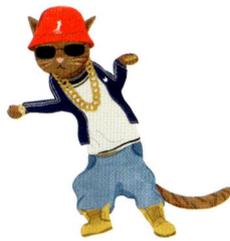

1980s-1990s

Hip Hop

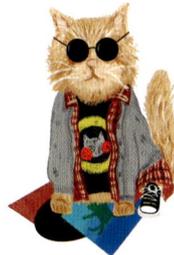

1990s

Grunge